100 Ways to Create FANTASY FIGURES

Francis Tsai

IMPACT

This book is dedicated to: my parents Sawako and Yung-mei, to whom I owe everything; my best friend, travelling companion and soulmate Linda; my sister Marice Atsumi; and all the friends and artists who have inspired me.

A DAVID & CHARLES BOOK
Copyright © David & Charles Limited 2008

David & Charles is an F+W Publications Inc. company
4700 East Galbraith Road
Cincinnati, OH 45236

First published in the UK in 2008
First published in the US in 2008

Text and illustrations copyright © Francis Tsai 2008

Francis Tsai has asserted his right to be identified as author of this work in accordance with the Copyright, Designs and Patents Act, 1988.

A catalogue record for this book is available from the British Library.

ISBN-13: 978-1-60061-119-3 paperback
ISBN-10: 1-60061-119-2 paperback

Printed in China by SNP Leefung
for David & Charles
Brunel House, Newton Abbot, Devon

Senior Commissioning Editor: Freya Dangerfield
Editorial Manager: Emily Pitcher
Editor: Bethany Dymond
Desk Editor: Demelza Hookway
Project Editor: Ame Verso
Proofreader: Nicola Hodgson
Art Editor: Martin Smith
Production Controller: Beverley Richardson

Visit our website at www.davidandcharles.co.uk

David & Charles books are available from all good bookshops; alternatively you can contact our Orderline on 0870 9908222 or write to us at FREEPOST EX2 110, D&C Direct, Newton Abbot, TQ12 4ZZ (no stamp required UK only); US customers call 800-289-0963 and Canadian customers call 800-840-5220.

Contents

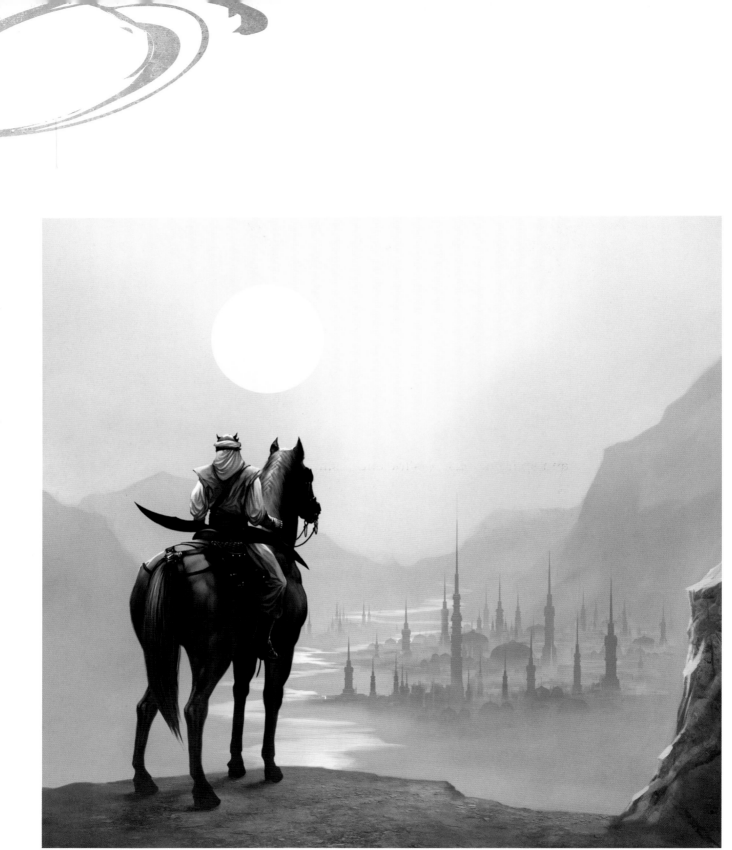

Valenar Elf

Foreword

A great many people think that art simply flows from an artist's hand like sparks from a wand; that because art is emotional and evocative, it must somehow happen magically. All by itself. We hear of the Art of Hitting, the Art of Cooking, the Art of Motorcycle Maintenance, and are deluded into thinking that it *is* magic. That it is beyond the average man or woman.

In truth, art is the end result of knowing a craft so well that it becomes intuitive and spontaneous. It is the end result of years of growth, which, for most artists, begins the day their first crayon touches their first sheet of paper. A certain small amount of native talent is essential, but equally important is the desire to learn the rules, the inside knowledge, the *tricks*. Perhaps the heart and soul are the magic, but knowledge provides the incantation.

Francis Tsai is one of those magicians who knows the spells. You might almost think of the volume you hold in your hands as a spellbook, full of the newts' eyes and dragon's scales with which we artists ply our craft. Pore through this tome and you will see revealed the hidden parts of the trade: colour theory, perspective, anatomy, composition, value control and all the rest of the ingredients that go into brewing up one in-your-face monster, invoking a demon from the nether-world, or imbuing a hero with the courage he needs to slay a dragon.

Francis is a high-level sorcerer, and he has generously divulged his secrets here for you to behold. Pay close attention, study the recitations, practice them daily, and you too can do magic.

Todd Lockwood

Introduction

If you're reading this book, you have probably had at least some interest in creating fantasy art, either professionally or just for pleasure in your spare time. I am fortunate enough to be able to make a living creating artwork for the entertainment industry, and because of this I often find myself being asked questions about it. How do you get a job as a fantasy artist? What kind of pens do you use? Is it OK to use reference material? How do you know what colours to use? And so on … My path to my current career was fairly lengthy and roundabout; I didn't take the traditional art-school route, and in fact never really learned the fundamentals of illustration in any rigorous, orderly way. It was not the easiest or best way to become a working fantasy artist, and I had to study every day to 'fill in the gaps' in my art education. After a number of years working as a concept artist in the computer games industry and as a freelance illustrator for books, comics, films and television, I have assembled a few nuggets of knowledge and some workflow routines that seem to have a certain degree of success. It is these that I want to share with you in this book.

It has never been a better time to be a fantasy artist. As I look around my studio library, I can see many examples of books and films that are fantasy related, or at least somehow influenced by this kind of imagery. Role-playing games have long been a primary source, but with all the recent advances in filmmaking technology, movies are now able to convincingly portray the kinds of worlds and beings familiar to fans of the fantasy genre. Successful films often spawn computer games and, increasingly, material can flow the other way too. This only benefits the traditional role-playing game and book markets, all of which results in more opportunities for skilled illustrators.

This book had a long genesis, which began back when I found that students and amateur artists (and even a few professionals) were asking me certain questions time and time again. I thought it might be useful to put together a list of 'Frequently Asked Questions' on my website. The more I worked on it the longer and more involved it became, because there was just so much material to cover. With some of the topics, it was hard to convey the information without an accompanying illustration to make the point, and it quickly grew beyond that of a simple FAQ. So I set it aside.

A few years ago, I started writing some short articles about different aspects of concept art and illustration for fantasy and science fiction art magazine *ImagineFX*. A few of the points I originally had in my FAQ showed up in these articles, but I was usually at the end of my allotted word count before I could convey enough information. It was an interesting dilemma – I could present my points in a fairly focused way that was limited in scope; or I could cover a wide variety of topics in a somewhat superficial way. So, when I was presented with the opportunity to create this book, I thought it would be a great way to impart some of the tips from the original FAQ, hopefully in a manner that is both broad in scope but also specific enough to provide some useful, practical advice based on my experience.

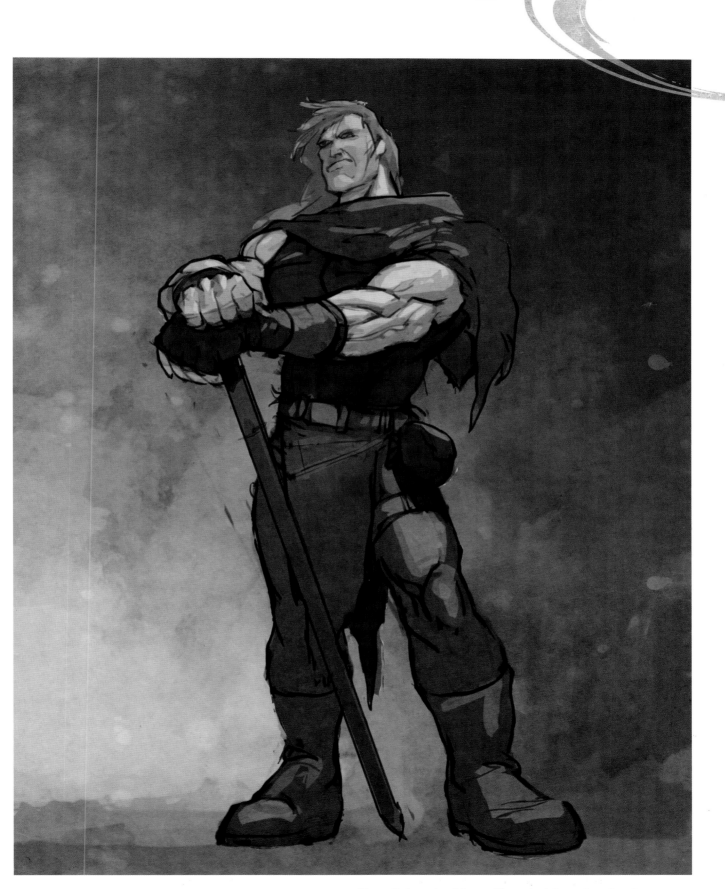

The preliminary sketch in most illustration jobs needs to show the art director your intentions as far as pose and composition go, and also give some idea of colour and tonal value without being too detailed or finished.

TOOLS OF THE TRADE

For an illustrator, tools consist of the actual equipment used to create the artwork. Until recently, these consisted solely of some variation of pencils, ink, paint and paper or canvas. However, in the past few years digital technology has advanced to the point where it can be difficult to tell the difference between art created traditionally and that made on the computer. In addition, peripheral equipment such as scanners and drawing tablets have continued to blur the boundaries between digital and traditional techniques and media.

In my own work, I occasionally use colour media such as watercolours or marker pens – there is definitely a sort of 'analogue charm' these methods have that digital media lacks – but the advantages of using drawing and painting software, especially for revisions and experimentation, for me make it the obvious choice in my work.

The physical equipment is not the end of the story, though. The term 'tools' also refers to the skills, strategies and personal work habits that allow an artist to create successful art. These are less obvious but just as important as the tangible tools, if not more so. These factors have more to do with an artist's workflow, problem-solving ability and general approach to conveying information through illustrations, and it is these that this book will explore, by looking at different ways of developing a sense of character in your images, as well as maximizing storytelling, creating mood to support an idea, and numerous other strategies.

A modern illustrator's studio should contain a combination of traditional and digital tools. In my own studio, I rely heavily on digital drawing and painting software, as well as peripheral devices such as graphics tablets and scanners to aid in the creative process.

In addition, there are some other basic general practices that can be used to develop your personal toolset. Studying and sketching your surroundings – people as well as objects and environments – trains your eye and mind in observational skills. Exercises like this help to build up your mental 'visual vocabulary', as well as improve your 'active observation skills', which simply refers to your ability to analyse your surroundings. For example, rather than simply noticing that a column has bolts in it, you should study the structure to understand why the bolts are there.

Finally, creating and maintaining a reference library is essential. For real-world material, if you rely on just your memory the best you can hope for is to get close; it is guaranteed that someone somewhere will know more about the object you're drawing than you do, and will know you haven't done your homework. Short of going to see something first hand, finding and using photographic references is therefore vitally important. In the past, illustrators created what were known as 'morgue files', which consisted of images clipped from newspapers and magazines that the illustrator might find useful for reference – clothing, costumes, locations, cars, whatever was needed for a particular assignment. These morgue files would occupy a lot of space, usually taking up several filing cabinets. So, yet another advantage of working with digital tools is that you are now able to find reference images on the Internet and store them on your computer, creating your own virtual morgue file.

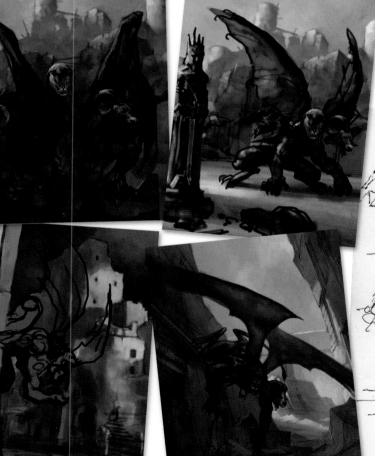

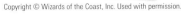

In this collection of preliminary sketches, I've created various layouts that use some of the same elements in different combinations. This would have been difficult or impossible to do with traditional materials such as ink or paint.

This page from one of my travel sketchbooks shows some notes and observations about a Mayan site in Mexico that I visited several years ago. I sketched some of the structures as they appeared, but also drew cross-section views, close-up analysis of the stonework, and an overhead view of the entire location.

100 Ways to Create Fantasy Figures

FIGURE DRAWING FOR BEGINNERS

For those who have never attempted a figure drawing before, the 100 Ways presented in this book might appear slightly daunting at first. This quick step-by-step demonstration reveals the key processes you need to get you started on your way to creating amazing fantasy figures.

A quick gesture line establishes a stance for the character

Try different ideas for costume elements without making any firm commitments

Refine the design decisions, losing the less important exploratory linework

Step 1:
Begin with the Gesture

The first mark you make when laying out a figure drawing should be a single line that captures the overall stance or movement of a character. Here, I've drawn a quick **gesture line** (in red) showing a simple standing posture; the character will lean slightly to the right, resting his weight on one leg. I've gone ahead and roughly blocked in the masses of the body, head and limbs. Notice the **counter pose** of the hips to the shoulders – this shows that the body is reacting to gravity.

Step 2:
Develop the Sketch

With the basic structure in place, I've started to lay in a more detailed drawing, **indicating design elements** such as clothing details, pouches, belts and various pieces of equipment. Don't get too detailed or finalized at this stage – it's better to keep moving around the drawing quickly, not making any firm commitments until you begin to get a sense of the overall image. This is a good time to **explore different options** with the lines of the character's clothing and gear.

Step 3:
Finalize the Drawing

Once all the major decisions have been made, I've gone back over the drawing with a darker, more definite line, cleaning up the sketch and making things a bit clearer. The cloak and other articles of clothing mask the character's stance somewhat, but having the **underlying structure** firmly placed in advance helps to make the drawing work, even with the **added complexity** of costume and props.

Practice Makes Perfect

Practise is necessary in any art activity – be it dance, music or drawing. Taking the time to hone your skills will only add to your effectiveness as an illustrator and help improve the pathways between mind and hand.

Keep a Sketchbook

Many artists carry around a notebook in which to record personal sketches, studies, experiments and random thoughts. The advantage of this habit is that it quickly becomes **a catalogue of ideas and explorations** that you can revisit in the future. It can often be tempting to make every image in a sketchbook as beautiful and finished as possible – in order to make it a nice object and a work of art in itself – but a good sketchbook should contain beautiful work *and* rough, scratchy drawings. All illustrators love looking at other artists' sketchbooks, but their main function isn't to be shown to other people – a sketchbook serves its purpose when it becomes **a personal record** of your thought processes and ideas, and can be used to help inspire you in your ongoing work.

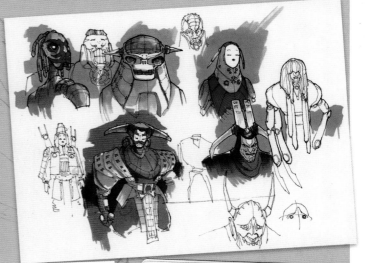

Documentation

Just like in school when you were asked to 'show your work', it is sometimes helpful to provide some documentation of your design processes. **Notes and sketches** like this can form a valuable part of your personal library – ideas can be reconfigured and reused in other situations as the need arises. I wouldn't recommend using finished designs this way, but preliminary and developmental sketches can often provide **'seeds' for new ideas** in other projects.

Figure Drawing

Even though much of fantasy art depicts imaginary and fantastical beings, it still needs to have a **firm basis in reality** in order to be convincing. Practising figure drawing with live models is a valuable exercise, and allows you to build up your artistic toolbox with **strong drawing skills and knowledge of anatomy**.

Travel Sketches

Making travel sketches forces you to **observe your surroundings** in a more engaging way, and helps you learn about the way people interact with their environment. Being able to place your figures and creatures convincingly in any setting is a valuable skill.

VISUAL COMMUNICATION

This is a concept that refers to the way in which an illustrator can convey an idea to the audience, and is one of the fundamental elements that this book will explore. The idea being communicated might be, for example, a mood, a character's personality, a sense of culture, an emotion, a conflict or an event. Once an idea for an illustration is clearly defined, the process by which the illustrator conveys and preserves the idea is known as 'visual communication'. Techniques of visual communication include the use of silhouette, proportion, scale, texture, lighting, hierarchy, level of detail and visual cues.

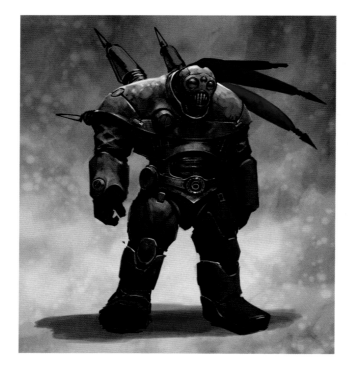

Hierarchy

The primary purpose of your drawings is to **communicate an idea**. When your drawings are clear and concise, your message will come through strongly. Planning line work to **eliminate unnecessary noise and clutter**, and to provide visual cues, improves the clarity of your drawing, and hence the effectiveness of its visual communication. Heavy lines indicate important outlines and edges, and should be used sparingly. Light and medium lines indicate details and textures; these should make up the bulk of the sketch. The idea of hierarchy can also be extended to value, concentration of detail, and texture. Using all of these ideas in conjunction can result in a simple, clear sketch that fully conveys all your design ideas.

Silhouette

Character design depends heavily on silhouette, which is also sometimes referred to as **the initial 'read'** of a character. The silhouette is the largest piece of visual information presented to a viewer, and as such is more important in terms of **first impressions** than things like textures, details and colours.

Lighting and Materials

One of the basic visual communication skills is the ability to render different lighting conditions and materials. The key to indicating materials lies in how they **react to light** – reflectivity, specularity, grain and texture are all traits that can be affected by lighting.

Indication of Detail

There is a balance to be struck in terms of when and where to use detail. Creating focus is a game involving colour, lighting and detail. Implying detail often does the job as well as carefully rendering every bit of it. In some cases, it is actually preferable so that you **don't focus undue attention** on places that do not need it, or that won't help to convey your message.

DESIGN

It is important to make a distinction between visual communication – the transmission of the idea – and design – the process in which you analyse a problem and formulate a solution. In computer game and film design in particular, a very common misconception about concept art is that it begins and ends with being able to draw or paint well.

Rendering skill is certainly extremely important to be able to clearly communicate your design, but that is only part of the equation. Keep in mind that the art you generate as a character designer is not **the end product** – it is simply the means to get to the end product, which is the film, game, television programme, music video, or whatever project it is that you are involved in.

One approach to design is to break down the design task into **manageable chunks** – separate silhouette studies from pose studies and from texture and material studies. The odds are against you 'hitting a home run' on all those different aspects with one single drawing.

Another aspect of design philosophy to consider is the balance between 'synthesizing' and 'originating'. By originating I mean coming up with something **completely unique**, that no one has ever seen before. Besides being almost impossible to achieve, you run the risk of losing or alienating your audience. Synthesizing refers to the process of combining different **familiar elements** that are rarely used together. This provides a familiar link for your audience and at the same time presents them with something new.

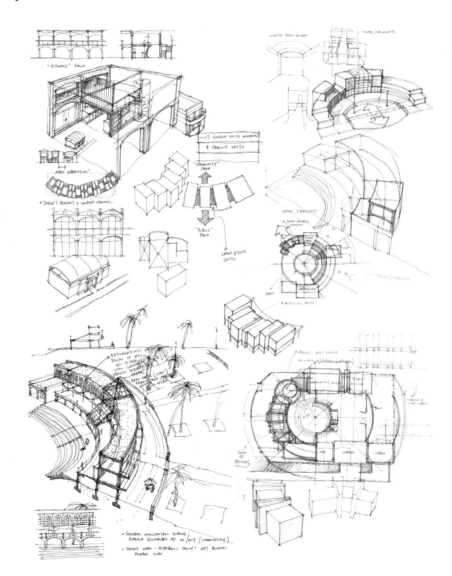

Artist's Tip

WHEN DOING DESIGN DRAWINGS SUCH AS THIS ONE SHOWN RIGHT, KEEP YOUR ERASER WELL OUT OF REACH. IF YOU FIND THAT YOU'RE DOING A LOT OF RUBBING OUT AND REDRAWING, YOU HAVE ACTUALLY STRAYED AWAY FROM THE DESIGN ASPECT OF THIS TYPE OF SKETCHING.

Design Drawing

This is a term that refers to the process of 'hammering out' and **refining a design** on paper. This process might involve drawing different views, 'X-ray vision' shots and handwritten notes. Typically this isn't something you show your audience, and it will often end up looking messy and almost incomprehensible. The goal with this type of drawing is to **explore different options** and develop an initial design idea.

EDUCATION AND TRAINING

One of the most common questions I hear is 'how do I get a job as a fantasy artist?' In truth there is no clear answer – many professional illustrators and concept artists found their way to their occupation through varied and roundabout ways. There are, however, some common elements in many artists' education and career paths that you could also benefit from.

Formal Learning

Working as an illustrator or concept artist requires a command of basic art skills and concepts, which can be obtained in a good, well-rounded art education. The type of learning you undergo will have an influence on your chances of success. In my mind there are two basic educational paths available that provide **a solid foundation**. First is an illustration-based education, which is one that concentrates on traditional art skills such as drawing and painting, colour theory, anatomy and perspective. This tends to be **an observational and documentary approach**, where students learn the skills necessary to reproduce what they see in real life in a variety of media. The second consists of a design-based education, which would include areas such as industrial design, product design, graphic design and architecture. This typically trains students in certain aspects of **visual communication** common to each field of study, but usually not to the extent that would be found on an illustration course. However, in the last few years, some courses have begun to appear that blur the boundaries between the two. Computer game design and entertainment design are now available as options for those seeking higher education, which can lead directly into careers in fantasy and science fiction art. An education in studio art techniques and/or art history can also be a great help in pursuing this line of work.

At first glance it might seem that an illustration-based education is much more useful for a career as a fantasy artist, but a design education can provide some very useful skills for a fledgling illustrator too. My own educational background is in architecture, and one of the most beneficial lessons I learned from it is knowing how to **formulate a design problem** so that I can then determine **a clear and effective solution**.

Developing Personal Strategies

As a fantasy illustrator, you will often be called upon to visualize people, objects and creatures that don't exist, or that are fantastical amalgamations of real, existing things. Because of this, an education in traditional art skills will benefit greatly from exposure to other fields of study too. As an artist or designer, the more '**visual vocabulary**' you have to draw upon, the better. Exposure to influences outside your primary area of interest is necessary in order to build up this mental library. The best way to accomplish this (and it is a never-ending process) is to expose yourself to as many different ideas and visual stimuli as possible. All artists tend to draw what they know, so expanding the database of 'what you know' makes you more versatile as an artist, giving you a broader range of material to draw from.

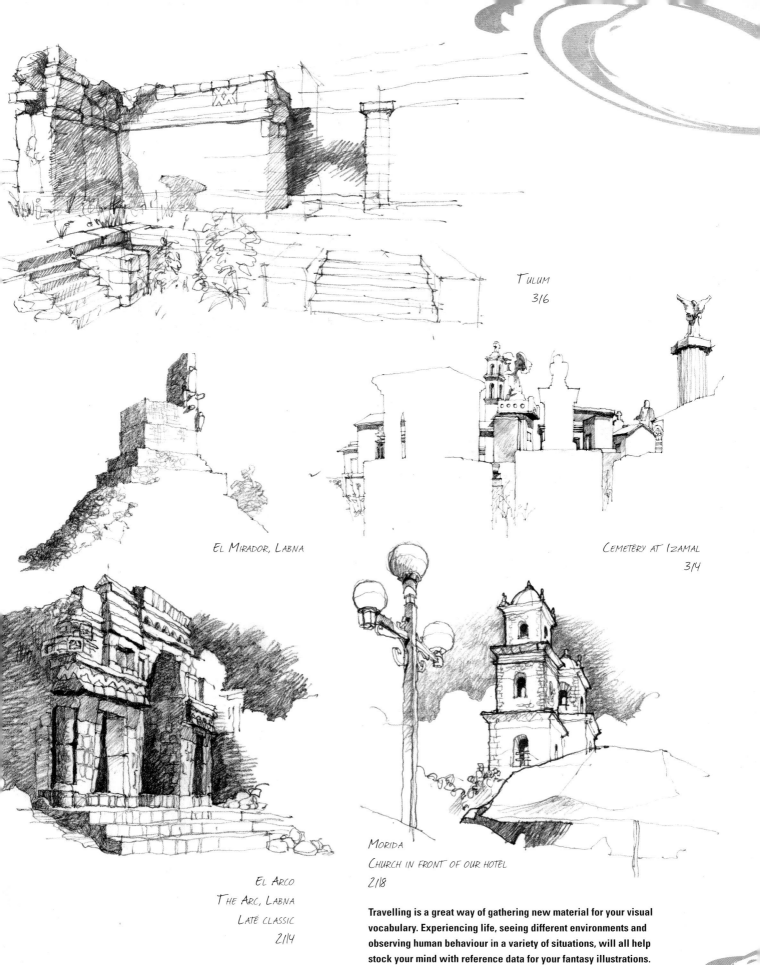

TULUM
3|6

EL MIRADOR, LABNA

CEMETERY AT IZAMAL
3|4

MORIDA
CHURCH IN FRONT OF OUR HOTEL
2|8

EL ARCO
THE ARC, LABNA
LATE CLASSIC
2|4

Travelling is a great way of gathering new material for your visual vocabulary. Experiencing life, seeing different environments and observing human behaviour in a variety of situations, will all help stock your mind with reference data for your fantasy illustrations.

CHALLENGES FOR THE WORKING FANTASY ARTIST

One of the keys to success as an illustrator is being able to balance the familiar with the unusual. In other words, as a commercial artist part of the job is being able to create artwork that an audience can relate to. There is a certain level of expectation you have to meet in order to successfully sell your artwork. At the same time, in order to stand out among the many thousands of artists working in the same field, you have to be able to bring something new to the mix.

It is very difficult to reliably come up with brand new, completely original ideas and concepts for every art job you happen to get. The strategy I have found some success with is to **introduce a new 'spin'** on an otherwise familiar subject. There are different ways to accomplish this. They include: combining influences or images that are not commonly associated with each other; introducing a single strange or alien element to otherwise very familiar imagery; or playing with an audience's expectations in clever and unexpected ways.

Along with developing tools and strategies such as those already discussed, it is also necessary to pay attention to the work being done by others in your field. You have to stay abreast of the kinds of imagery that seem to be making the biggest impression on your audience, what styles appear to be on the wane, and what kinds of things feel like 'flavour of the month'. This is not to say that you should always be chasing the market with your style; it is important to find and then maintain and develop **your own voice** in your artwork. The bottom line is that as you do this you should also be constantly aware of the environment and market you are working in.

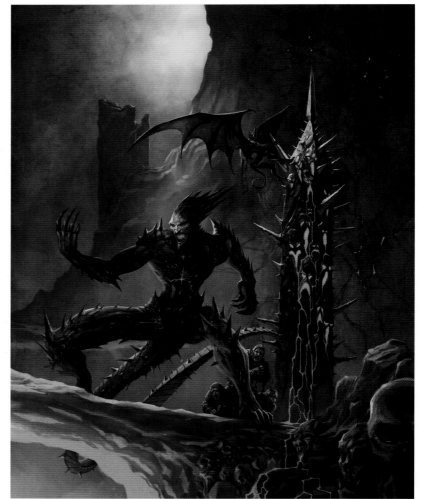

Working with an art director at a large publishing company like Wizards of the Coast (for whom this image was created) is a collaborative process. As an illustrator you are being hired for your ability to visualize fantasy worlds and characters, but you do not have total freedom to draw or paint whatever you want. The art director usually has a list of requirements from a number of different parties, and creating an illustration becomes at least in part a problem-solving exercise, where you are trying to find the best way to satisfy many (sometimes conflicting) conditions.

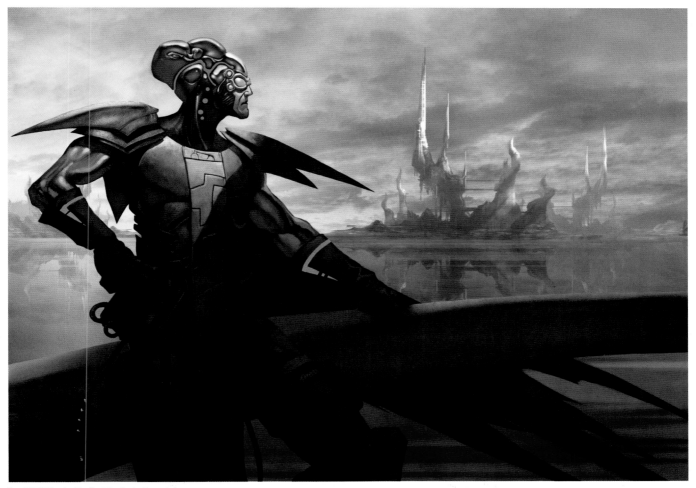

Images like this can sometimes be used large, as game covers, but more often will end up as trading cards for games such as 'Magic: The Gathering'. Although the final art for these cards is very small, sometimes as little as an 4cm (1½in) wide, the same care and attention goes into each of these illustrations.

One of the first things you have to establish for yourself as you begin a project is the '**big picture**'. Your client may have some ideas about mood or a certain character, or perhaps he wants magical flying armoured hippos in his game, just because he thinks they are 'cool'. As the artist hired to bring this vision to life, you have to be able to take a step back and perceive the project as a whole, so you know what parts are truly important, and what parts obscure the big picture. Do flying hippos fit into the world you are creating? If not, what kind of spin can you put on them so that they make

sense with your vision? This could involve a lot of **thinking and research** on your part, even before you put pencil to paper.

This book should in no way be considered as a replacement for a good art education or experience in the field – it is simply one working illustrator's collection of ideas and strategies; things that seem to have worked consistently well for me in the past. My hope is that it can provide you with some useful **information and inspiration** on your path to becoming a successful fantasy artist.

Understanding the Basics

Any creative endeavour has a greater chance of success when it is built on a solid foundation. For an illustrator or character designer, a sound footing comprises some basic knowledge and a number of different competences. This section looks at some of the fundamental tools and skills any artist should have in his or her visual toolbox, and will also define some important concepts.

Illustration inspired by the Hindu goddess Lakshmi, goddess of wealth, fortune, love and beauty.

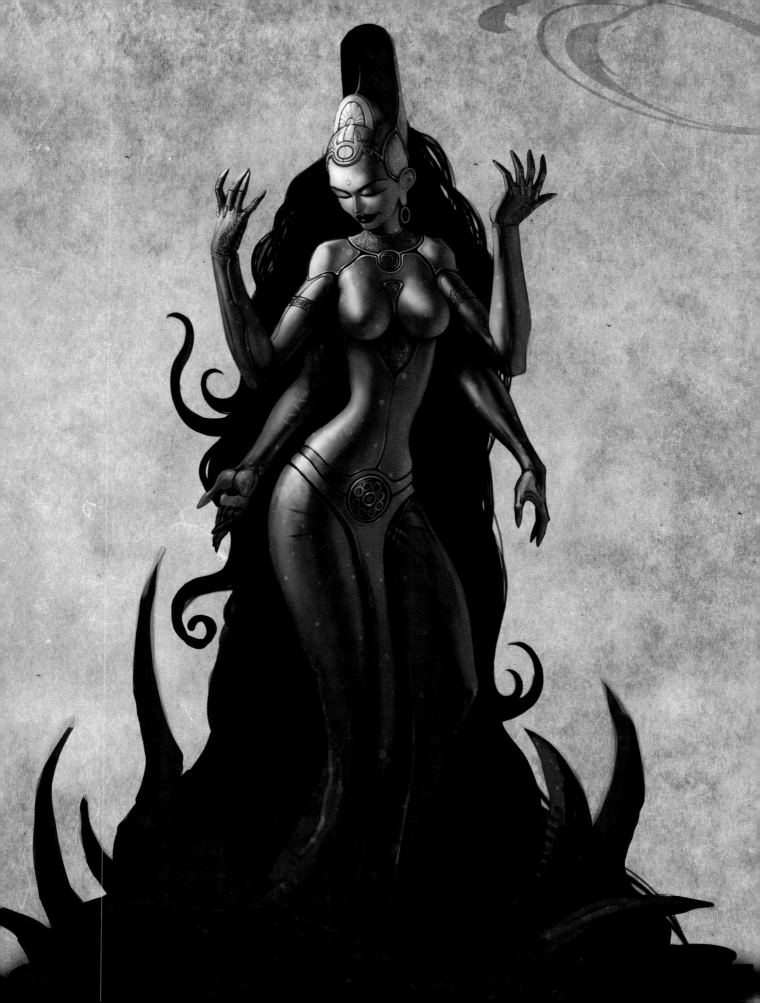

Understanding the Basics

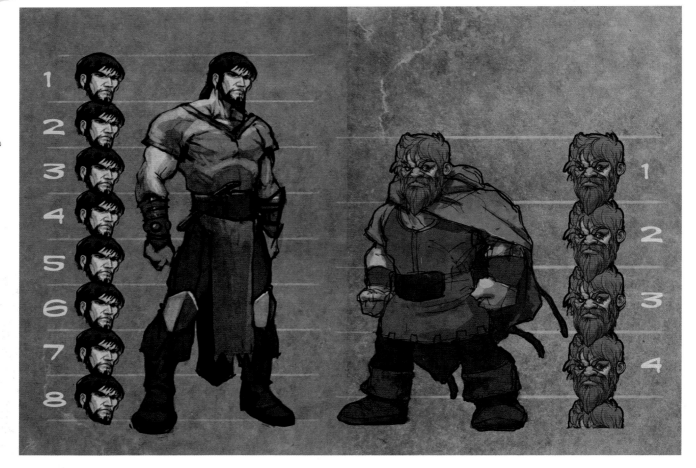

Heads for Heights

The term '**proportions**' refers to the relative sizes of different parts of a character's body. For fantasy figures, you can obtain some visually interesting results by altering some of the **dimensions** of a normal human body. One way to look at this is to split up a character's vertical height into **units** based on the length of their head. Most real people have proportions of roughly six heads to their height. By increasing the number of head-lengths in a character's stature, he or she can be made to feel more **heroic** and larger than life. On the other hand, a character that is fewer heads tall exhibits more of a **humorous** or endearing style of heroism.

THIS 'HEADS' MEASUREMENT IS ONLY INTENDED TO BE USED AS A ROUGH, GENERAL RULE-OF-THUMB. UNLESS THE CHARACTER IS DEPICTED STANDING STRAIGHT UP AND FACING THE VIEWER, IT CAN BE DIFFICULT TO BE PRECISE ABOUT THE NUMBER OF HEADS IN THEIR PROPORTIONS. THE BEST INDICATOR OF SUCCESS IS THE 'FEEL' – ALWAYS ASK YOURSELF, DO THE CHARACTER'S PROPORTIONS CONVEY THE SENSE OF PERSONALITY OR PHYSICALITY THAT YOU ARE LOOKING FOR?

Ideal Head and Face

Just as there are ways to distort the body proportions of your characters (see page 20), the **dimensions and size relationships** within their facial features can also be altered to suggest different personality traits. To begin with, study the **proportions** of an ideal head and face so that you know how to deviate from it when desired. The head in profile view fits roughly inside a square. If you examine the features in the front view, you can see that the head tapers gently from the dome of the skull to the bottom of the chin, and that the face is approximately the width of five eyes. A triangle drawn from a point between the eyes to the widest points of the mouth can be used to determine the width of the nose.

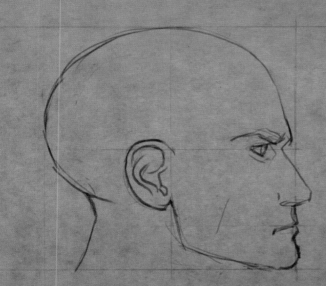

Subdividing the square into four smaller, equal squares establishes some important landmarks, such as where to place the eyes and ears

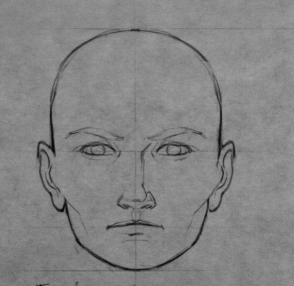

The head is more elongated in front view, and does not completely fill the square

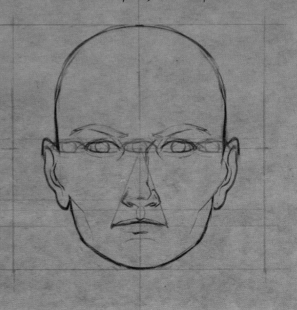

The distribution of the features from the front view tends to fall into a specific symmetrical geometry

The figure follows a general
arcing line that is picked
up by the arm, upper
torso and legs

Secondary lines, such as those of
the staff, shoulders and head,
should not contradict or confuse
the overall action line

Gesture Line

When sketching a figure, it is often useful to distil the
drawing into a single gesture or movement, to attempt to
convey a distinct visual message. By starting an illustration
with a **line of action**, you create an overall sense of the
motion or **attitude** of the character, which all subsequent
drawing and rendering should adhere to. In this rough sketch,
a decisive stance is established by the feet being spread and
the upper torso leaning back to accommodate the weight
of the weapon. If I were to continue working on this image,
I would be careful to maintain the sense of **posture** that
was established with this initial action line.

The position of the head is often a good indicator of the 'personality' of the overall pose. The tilt/turn of the head conveys much of the information contained in body language

The red lines in the illustration correspond to the angles formed by certain paired elements in the human body. Lines drawn through the shoulders, hips and knees show how the body responds to gravity when the centre of mass is shifted

Counter Pose

In life, people rarely carry themselves in a perfectly symmetrical, rigid state – more often, they lean to one side or another, or rest their weight on one leg. Bringing this **sense of reality** into your character design can help convince the viewer that your character is a living, breathing personality. One way to do that in an illustration is to use *contrapposto*, an Italian word meaning 'counter pose'. In this illustration, the lines through the hips and the shoulders tip in opposite directions – the character shifts her weight to her left leg, using the right leg as a brace. She tips her upper body to the left so her **centre of gravity** is over the supporting leg. The result is a **dynamic pose**, which gives a strong indication of the character's confident attitude.

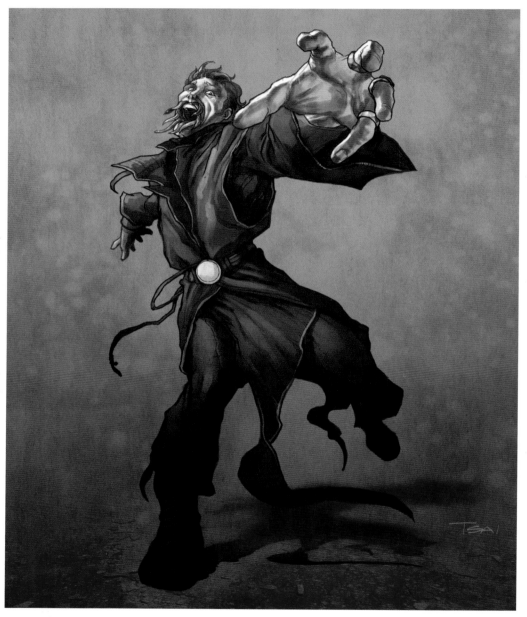

Irthicax Vane

When you see people in real life, only occasionally will they be standing directly in front of you. More often than not, some part of their body is turned away from you, or towards you, creating a situation where the limbs or torso are viewed at such an angle that certain body parts are **obscured** by those elements closer to you. This perspective effect is known as **foreshortening**. Figures in motion or in some kind of **active pose** will almost always exhibit foreshortening in some part of the body. This can be a very useful tool in generating **interesting shapes and silhouettes** in your illustrations, and in general results in more engaging images.

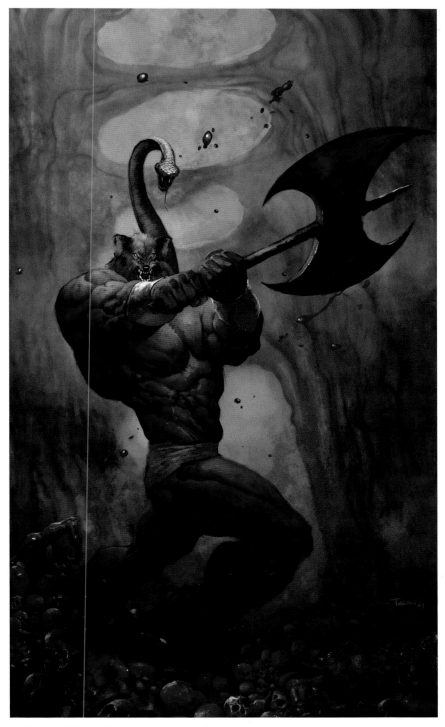

Molydeus

The **Colour Wheel** might already be familiar to you if you have read art books or taken a painting class. It is the relationship between the colours on the wheel that interests illustrators. Colours directly opposite each other are called '**complementary**' and, when used together in the right combination of saturation and intensity, can add vibrancy to an image. In this illustration of a two-headed monster, the figure is primarily red, as is the majority of the ground underneath him. The backdrop is rendered in varying shades of green, which is the complementary colour to red on the wheel. As the green shades are more muted and less saturated, they become **secondary** to the bright and dominant red. This allows the character to stand out more dramatically from the rest of the scene and creates a visually intriguing '**vibration**' between the foreground and background colours.

Having a small Colour Wheel to one side as you are working can be a handy reference to help keep your colour strategy clear.

Understanding the Basics

Lakshmi

Lighting is a critical tool in communicating ideas visually. Not only can lighting create a certain mood, it can also provide a means of **indicating form** in a very unambiguous way. The lighting scheme in this illustration consists of a cool green light coming in from the left, and a warm orange secondary light source from the right, possibly reflected from a red surface outside the frame of the picture. Having light sources coming from different directions like this creates **core shadows** on the forms, where the surfaces turn away from either light source. The gradation from cool lit surface to dark shaded surface and back to warm lit surface tells the viewer the shape of the object. The key is to **keep the lighting 'logic' consistent** throughout the image.

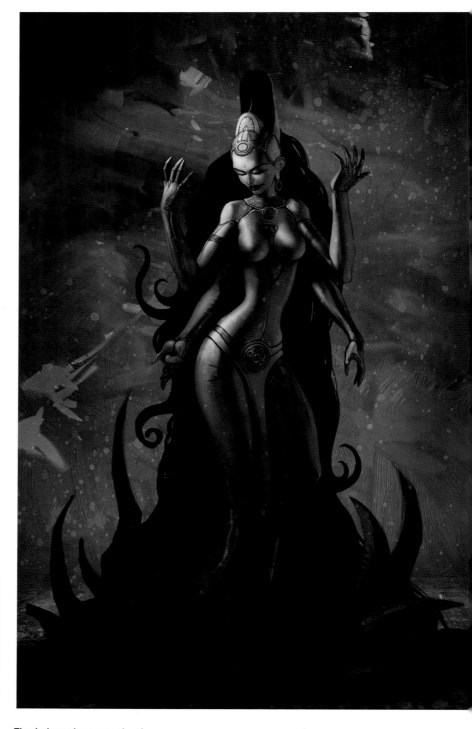

The darker value separating the surface lit by the main light source and the surface lit by bounced light is called a core shadow.

Combine Lighting and Colour Theory

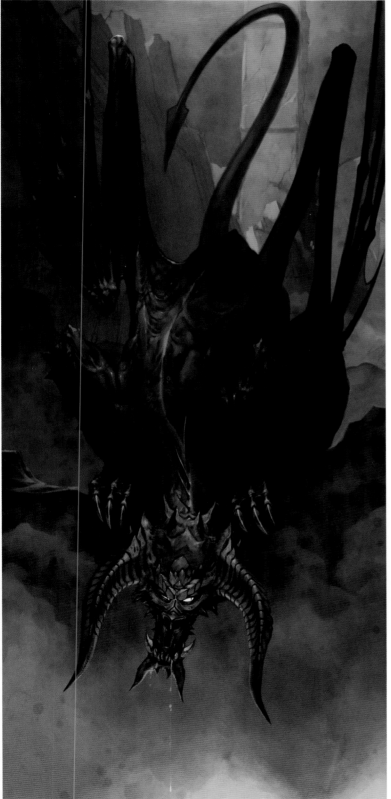

Black Dragon

The previous two pages have explored the principles of using first colour and then light. Once you have understood these two basic concepts, you then need to appreciate how to make them work together for a successful, finished image. Establishing a **definite lighting scheme** in your painting is essential for being able to convey information clearly. Taking this strategy further, combining a lighting scheme with the principles of colour theory can **improve the clarity** of your paintings. You can contrast warm source light with cool bounced or secondary light, or alternatively create mixed light sources using complementary colours. In this illustration, warm red-orange light from below balances the cool green light from above.

Using complementary colours as a basis for the lighting design adds vibrancy to an image.

009 Remember that Style is not Design

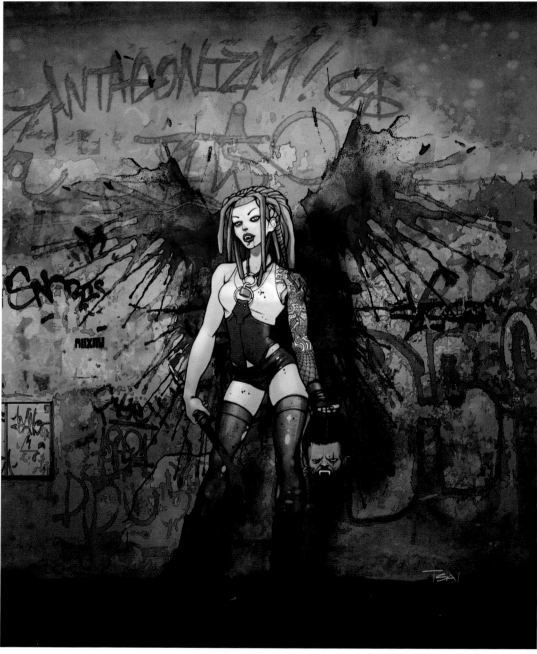

Vamp

A critical concept to keep in mind is not to confuse **rendering style** with **character design**; when drawing figures it is important to be able to distinguish between illustration and design. This illustration is done in a very graphic, cartoon-like style, but the fundamental design elements of the character (hairstyle, tattoos, the lines of her clothing, etc.) are not dependent on how the illustration was created – the **character design should be recognizable** whether it is drawn as a cartoon, painted in oils, or created as a 3D model for a computer game. Rendering style can help reinforce a **design statement**, but the basic design should be able to stand apart from the manner in which it is illustrated.

Green is the 'spot' or key colour here; the other colours are subservient to it

If all the colours are used in a fully saturated way, the result is garish and unfocused

Saturation Point

With digital painting software, it can be tempting to lay down a lot of colour and this makes it easy to end up with an oversaturated image. That's not to say saturated colours are never appropriate, but **moderation** is usually a good idea. One simple approach is to determine a **dominant colour**, and keep other shades more subdued. In this illustration, two versions of the same image are shown with different **levels of saturation**. On the left, most of the image is fairly desaturated, and the vivid green of the tentacle 'pops', making it a focal point. On the right, saturated colours have been used all over the image, reducing the impact of the green tentacle. Also, blue and red, two of the three primary colours, have been used at an almost equal intensity. There is no hard-and-fast rule saying that you shouldn't do this, but unless it is **a deliberate design decision** it is better to avoid it.

011 Use Line Art to Save Time

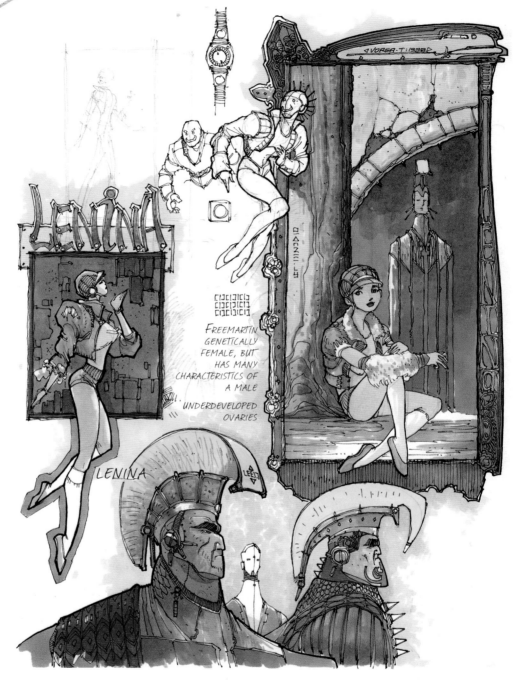

FREEMARTIN
GENETICALLY
FEMALE, BUT
HAS MANY
CHARACTERISTICS OF
A MALE

UNDERDEVELOPED
OVARIES

LENINA

Lenina Design Sketches

Illustration and design can be done in a variety of different media and using a number of techniques. Most of the artwork in this book takes the form of either coloured line art or tonal paintings, or a combination of the two. Line work has the benefit of being **quick and iterative**, requiring less of an investment of time. Line art can be used to **indicate detail and texture**, which might sometimes be more labour-intensive

in a painting. In this sketchbook illustration, character design ideas were drafted in black and white with a pen; most of the details in the image are delineated by the line art, and colour is used in a very simple, almost diagrammatic way. Relying on line art techniques in the beginning of the design process can speed things along, by allowing you to **explore ideas and colour schemes** in a more rapid, less committed way.

Fallen Kings Layout Tests

Breaking up the illustration task into more **manageable parts** makes the overall task much easier. Rather than designing the character as you are deciding on the composition, try to have at least a rough idea of the form the character will take before laying out the final illustration. These colour sketches show different attempts to create a composition featuring a three-headed beast (see page 50 for the finished illustration). Importantly, the character design had already been completed at this point, which allowed me to **concentrate** solely on the effect achieved by different arrangements.

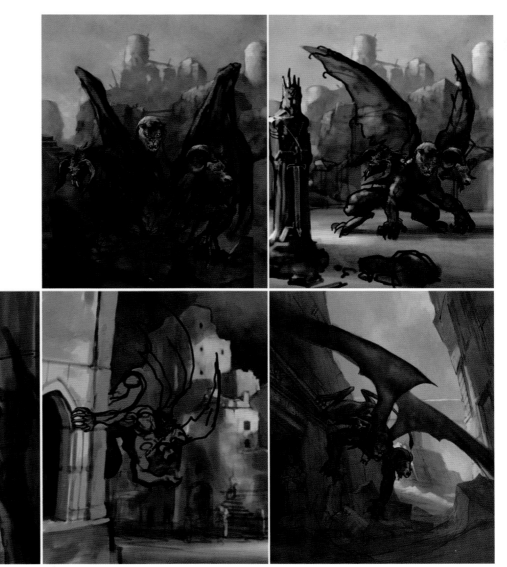

013 Differentiate Between Illustration and Documentation

The process of creating an accurate turnaround drawing will involve moving back and forth between views, correcting minor geometry errors

This is a valuable exercise in refining and documenting a character design, and can reveal inconsistencies or design flaws that are not always apparent in a sketch

Winged Succubus Turnaround Drawing

On page 28 the distinction was made between illustration and design. To reiterate, illustration generally comes after the character has been conceived, while design is largely a mental process in which you determine the character's features and **employ visual tools** to communicate those ideas. The term 'documentation' refers to the type of drawing that is intended **solely to present design information** for use in another medium. Most of the images in this book fall into the category of illustration, and are intended to convey a range of factors including mood, action, location and emotion. A documentary piece should be devoid of these 'extras', with the sole aim being to provide an outline for another party, such as a sculptor or digital 3D modeller, with **little or nothing left to interpretation**, so that an accurate model of the character can be created.

Appreciate the Value of Line Weights

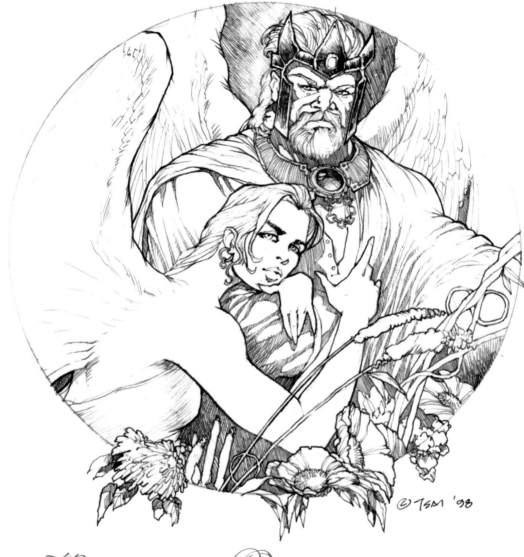

The King and Queen

With painting, it is possible to indicate a huge variety of materials, textures and colours, but how can you convey the same kind of information with a line drawing? Compared to painting, line art has a somewhat limited ability to transmit your message; however, one aspect that you do have great control over is line weight. By **varying the thickness and strength** of the lines that make up a drawing, it is possible to communicate a fairly large amount of information. In this illustration, thick lines are used to indicate edges of forms, where one edge overlaps another. Lighter-weight lines are used to suggest textures, folds and materials and are much more abundant than the heavy strokes. In general it is better to **be sparing with the thick marks** — overusing heavy lines undermines the impact of the other lines and can result in a messy, unintelligible drawing.

Researching the Character

A lot of work goes into creating a good fantasy illustration before the artist even puts pencil to paper or makes the first mark on the screen. This section looks at the background work you can do to gain a clear idea of who your characters are and the nature of the world they live in, which will make the design process easier and more enjoyable. It is not necessary to have every last detail determined ahead of time, but rather just the main landmarks – personality traits, occupations or character archetypes – that will provide you with a definite direction and end goal.

The creature in this illustration comprises a number of established figures in the fantasy mythos – creating this image required a significant amount of research and gathering of reference material.

Ghost Battle in the Lost Empires of Faerûn

One very effective way to begin a figure design task is to conceive the character's story. A **narrative can come from any aspect** of a character – culture, occupation or history – depending on what kinds of things you want to emphasize in your illustration. Creating a story for your characters helps to solidify them in your mind, making them seem more real. Having a sense of where your characters came from, what their values are, how they would react in certain situations, even what they like to have for breakfast, is helpful in many different ways. Some of these factors may never appear in the image, but they are important because they help to **create a complete sense of the character** as a living and breathing personality. This sense of story will almost always come through in the final illustration.

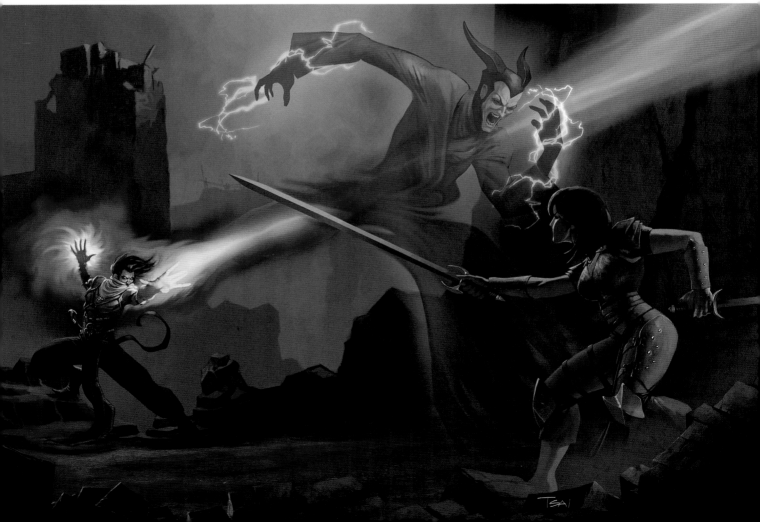

Understand the Character's World

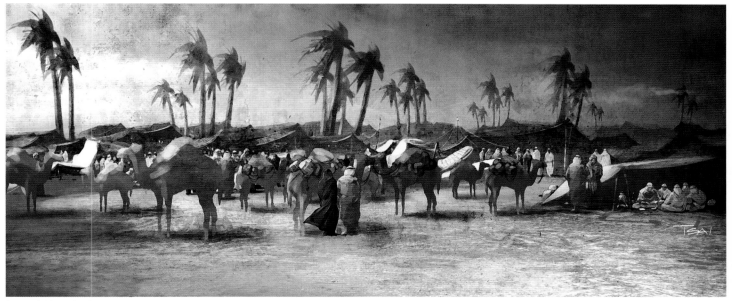

Copyright © Wizards of the Coast, Inc.
Used with permission.

Sands of Anauroch

One of the most important things to determine is the kind of world that your character inhabits – time period, climate and customs. Just like in real life, these factors have a significant effect on someone's **general appearance**. Having a deep understanding of the world your character comes from provides you with **ready answers** to many of the questions you will be asking yourself as you draw. This illustration, created for the fantasy role-playing game 'Dungeons and Dragons', shows a very specific society made up of nomadic desert dwellers. Rather than concentrating on a single figure first, I've shown a fairly large slice of the world that the characters inhabit. Creating imagery like this can help **maintain a 'big picture'** sense of their world, which is a tremendous advantage in the design of an individual character.

Exploring different conditions in the same environment can be helpful in firmly establishing the nature of a location in your mind.

Copyright © Wizards of the Coast, Inc. Used with permission.

The Pink Conch

In the same way that knowing about a character's world can provide you with many clues in designing **a convincing individual**, knowing how a character spends most of their time and energy can also be a valuable source of **visual inspiration**. In fantasy stories and games, main characters are usually some form of adventurer, but aside from the heroes and supernatural beings, there are plenty of townspeople, merchants, clerics and other **supporting roles** that you might like to illustrate. In this recent illustration for Wizards of the Coast, I was asked to provide an image of three sex workers at the Pink Conch bordello. Their occupation has informed the design of their provocative costumes and 'come hither' expressions.

Artist's Tip

ALTHOUGH YOU ARE DEALING PRIMARILY WITH FANTASY ELEMENTS, BRINGING IN REAL-WORLD VISUAL CUES (BY REFERENCING IMAGES AND DESIGNS FROM REALITY) CAN HELP MAKE YOUR IMAGES MORE CONVINCING. HOWEVER, YOU DON'T WANT TO FOLLOW FACTUAL REFERENCES TOO CLOSELY, SINCE DOING SO HAS THE POTENTIAL TO TAKE THE VIEWER OUT OF THE WORLD YOU ARE CREATING. INSTEAD, THE INTENTION SHOULD BE TO 'REMIND' THE VIEWER RATHER THAN EXPLICITLY 'QUOTE' FROM REAL-WORLD INSPIRATION.

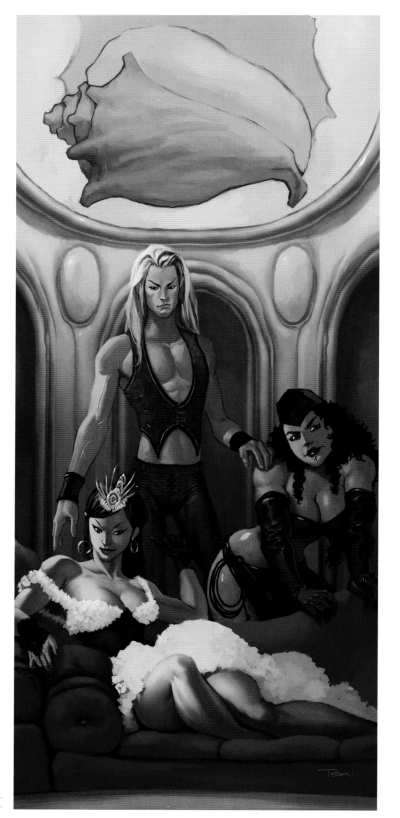

Incorporate Culture

Drow of Praxirek

One important concept to keep in mind as you work is the culture of the character. Try to imagine the world that the character inhabits, and picture the **cultural aspects peculiar to that character**. For example, in this illustration the spider motif has been used in the drow clothing and armour designs. The choice to use spider and web imagery for drow characters is not an arbitrary one – it is a direct expression of certain elements of the drow culture, specifically the subterranean origin of the drow elves, their affinity for the arachnid creatures found there, and even one of their religious icons, Lolth the Spider Demon Goddess. Incorporating the character's culture into the illustration will bring **added depth and meaning** to the piece.

Mordak Brelliar

Part of the task of creating a successful character involves **removing or minimizing details** and design elements that contradict or confuse the message. The more the various ingredients in the illustration contribute to **a coherent whole**, the clearer the meaning will be to the viewer. In this image of a sorcerer, the costume and prop design are **simple and consistent** with a person who attacks and defends himself using magic alone. He does not wear heavy armour, or carry a sword, a knife or other weapons and equipment. These are factors that would have contradicted the notion that the character is primarily a user of magic, and would create **ambiguity** in the image.

Make Notes to Organize Your Thoughts

BLACK METAL
SUPPORT TUBE

ATTENDANTS HARVESTING THE GODLY ELIXIRS
GENERATED BY HIS BODY

OBESE – BODY IS BLOATED
SO MUCH HEAD ALMOST
DISAPPEARS;
IMPLANTS/ACCESS POINTS FORM
A SORT OF COLLAR

Notes on a Monster

Using written notes to **record your ideas** is a very useful but sometimes overlooked step in the character design process. When starting out on a new idea, notes can be used to log fragments of designs that may not have a clear visual representation yet, or suggest **different directions** to investigate later. You've heard the phrase 'a picture is worth a thousand words', but sometimes written comments can be worth a few pictures too. Notes can serve as reminders without committing to **specific design choices** too early in the character's development.

Researching the Character

Artist's Tip

'Knowing your audience not only means understanding who is looking at your work, but also what other material they are being exposed to. Part of the job of researching an illustration or design task is to look at other similar work in the particular genre and style in which you are working. The Internet is extremely useful for this kind of research, as is going to bookshops and getting a first-hand look at the kind of artwork that is already on the shelves.

Little Orc

If you are aware of the people who will be looking at your work, you can keep them in mind to help with **decision-making** as you design. For example, if you are creating characters that will be seen by young children, it pays to favour clean line work, simple shapes and forms, and bright colours. If on the other hand your audience is older – teenagers or young adults – a more detailed, complex art style is more appropriate. In this image of a young orc-like creature, I have deliberately chosen **a simplified style** that is not hyper-realistic or overly grotesque. My intention was to create a fantasy illustration that would provide a way for people not familiar with fantasy art (such as young children) to relate to the character.

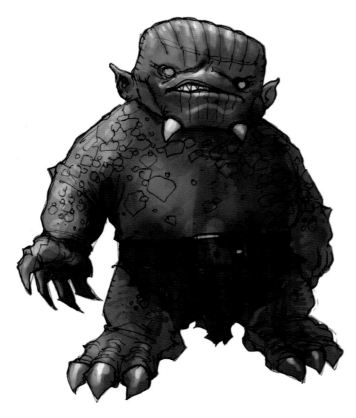

Explore Character Archetypes: Death

Your Task Awaits

The image of Death as a sentient being exists in almost all cultures. In Western society, he is most often known as the 'Grim Reaper' and is associated with skull or skeleton imagery, symbolizing the decay of the body. Scythes and **dark hooded robes** usually accompany this archetype. The most compelling quality of the Death character is the **sense of the unknown** that he conjures, forcing us to question whether something exists beyond life. Invoking this quality by hiding the face or obscuring the eyes so that **expression is unreadable** is critical in any portrayal of Death.

023 Explore Character Archetypes: The Wizard

Sorcerer

The wizard archetype is well known in the fantasy world. The genre is often referred to as 'Sword and Sorcery', which indicates just how important the magical aspect is within it. The wizard or sorcerer character is often depicted as **an older, scholarly figure** who has devoted his life to the study and practice of his craft. Rather than depend on his physical abilities in an adventuring career, he has chosen to develop his mind in order to master the magic arts. The key strategy in illustrating a wizard is to make some sort of **visual reference** to his reliance on powers beyond his bodily capabilities.

Artist's Tip

SPECIALIZED 'CUSTOM' PAINT BRUSHES CAN BE CREATED FOR INSTANCES WHERE YOU WILL WANT TO USE CERTAIN KINDS OF IMAGERY OVER AND OVER AGAIN. FOR THIS WIZARD ILLUSTRATION I USED VARIOUS CUSTOM 'ARCANE SYMBOL' BRUSHES CREATED BY ARTIST STEPHANIE SHIMERDLA. FOR MORE INFORMATION, GO TO:WWW.BRUSHES.OBSIDIANDAWN.COM.

Explore Character
Archetypes: The Holy Man

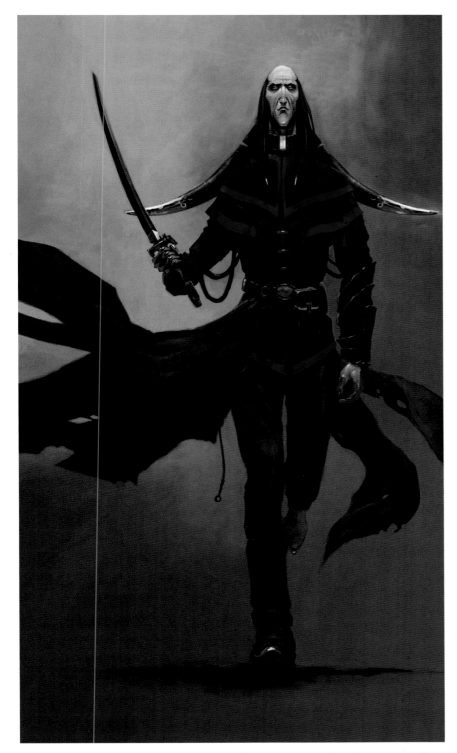

This holy man has a serene, calm air to him, but personality is
not tied to a particular archetype. A fiery, angry character with a
much more intense expression could also work for this archetype.

Preacher

Although there are some similarities between this
archetype and the wizard character, there are also
crucial differences. Usually the holy man appears
as a **patriarchal authority figure** representing
a religious or clerical movement or institution.
Like the wizard, his power comes from something
greater than himself, but in this case it is not
magic but God. The holy man acts as a conduit
for **supernatural and metaphysical powers**
and can be depicted with some artefact or symbol
of the weight of his office. This might be a staff,
religious item or icon, or a **consecrated weapon**
such as this preacher's sword.

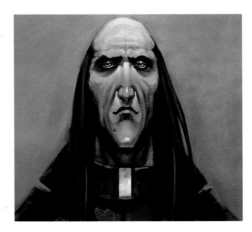

025 Explore Character Archetypes: The Holy Woman

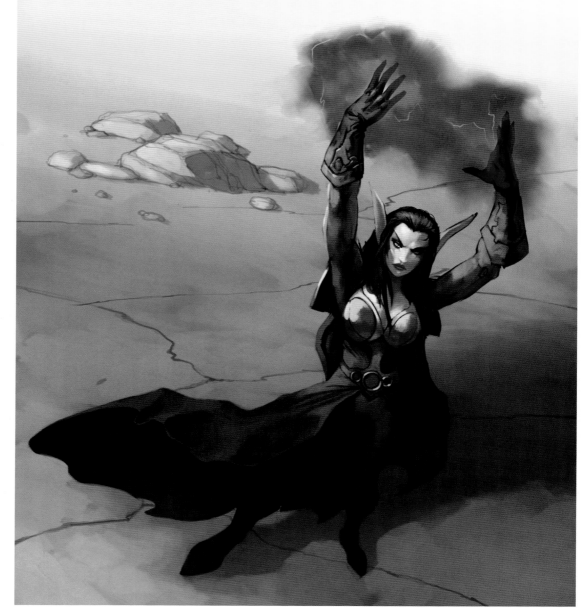

Night Elf Priestess

The female holy character is similar to the male version, but while the holy man takes on father figure roles, the holy woman represents the **maternal aspect**. Like the holy man, the holy woman or priestess derives her power and accoutrements from her station as a representative of a larger, more powerful and authoritative institution. In a similar manner to her male counterpart, the holy woman can express her station by wielding or displaying some **object or artefact** of her religion.

Explore Character Archetypes: The Sorceress

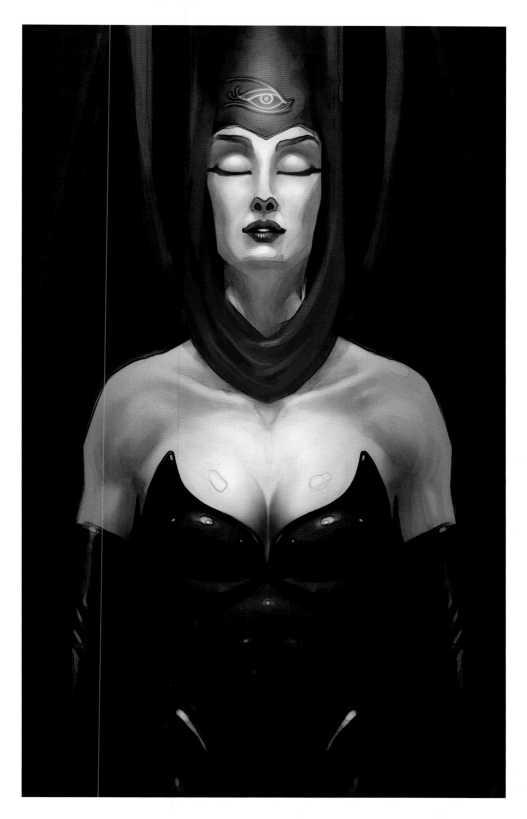

Telepath

A popular character archetype that often appears in different fantasy settings is the goddess/sorceress/earth mother figure. This character is the female counterpart to the wizard/sorcerer archetype and is similar to the priest/priestess character. Like the wizard, the sorceress often possesses a power or ability rarely found in the general population, and has honed this ability through a lengthy period of study or apprenticeship. Her choice to pursue this path might have been influenced by an **inherent quality or skill**. In this illustration, the character depicted is a telepath – she was born with a certain talent for **mind control**, which had to be nurtured and trained in order to develop fully. The formal stance and obvious concentration of the character suggests **a high level of discipline**.

Explore Character Archetypes: The Hero

Gorok the Brave

The hero is the character that most people identify with, and is consequently the archetype that is most **open to interpretation**. In theory, the hero of a fantasy story can come from any of the other character archetypes, but in most cases the typical hero is more of a generic or 'everyman' character. This allows an audience to relate to him by imprinting something of their own identity on to the character. A hero is often **defined by his quest**, wherein the adventures he experiences cause him to change in some significant way. The hero's main quality – for example, physical strength, skill with a particular weapon, or a special ability such as communicating with animals – should be expressed with utmost clarity. Probably more so than the other archetypes, the hero's key '**selling point**' cannot be complicated or obscured.

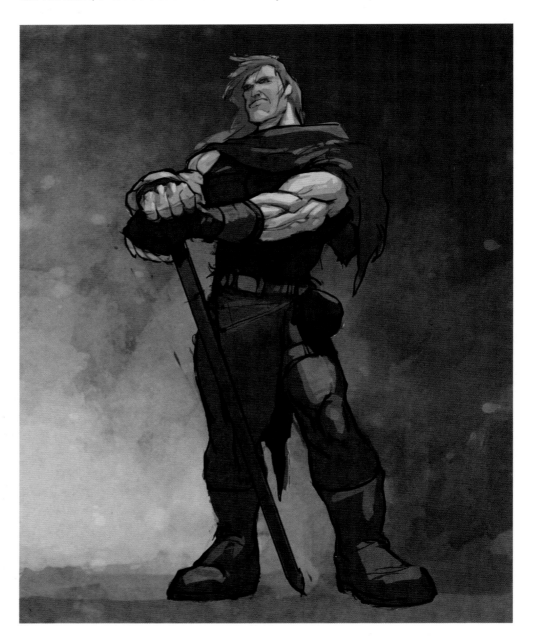

Explore Character Archetypes: The Jester

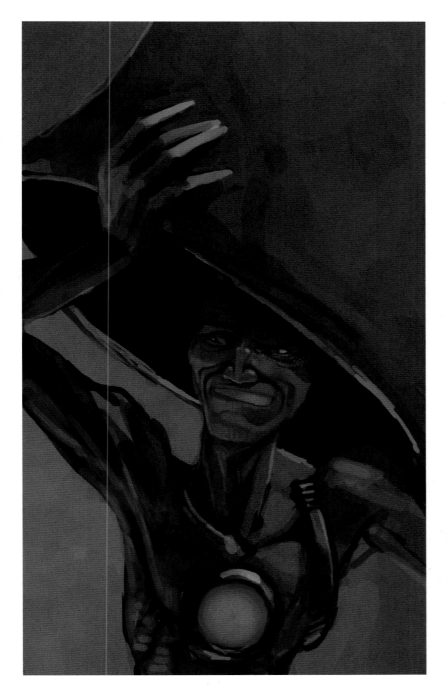

Duvor the Strange

In any story, be it a film or a graphic novel, it is often useful to create a secondary character to work with the primary roles. The jester or comic figure usually accompanies the hero and acts as a **humorous foil** or narrative device, providing a **mechanism for exposition** in situations where the hero on his own might be too limiting. In the same way that adding a spot of complementary colour can add a visual spark or increased vibrancy, injecting a small element of humour can provide welcome relief in an otherwise grim or morbid storyline. **Facial expressions** are key to creating this comedic appeal in a character, with sparkling eyes and infectious smiles top of the agenda.

Artist's Tip

SOME CHARACTER ARCHETYPES RELY MORE HEAVILY ON DIALOGUE AND NARRATIVE INFORMATION. IN CASES SUCH AS THIS, IT CAN BE USEFUL TO IMAGINE SHORT SNIPPETS OF DIALOGUE OR ACTION THAT HELP TO DEFINE WHAT THE CHARACTER IS ABOUT. WITH CERTAIN CHARACTERS I'VE SOMETIMES FOUND IT HELPFUL TO IMAGINE WHAT THEIR VOICE OR ACCENT MIGHT SOUND LIKE, HOW THEY SPEAK, AND SOME UNIQUE TURNS OF PHRASE THAT THEY MIGHT USE. TECHNIQUES LIKE THIS HELP YOU TO GET INSIDE A CHARACTER'S HEAD AND FILL OUT THE CONCEPT.

029 Explore Character Archetypes: The Beast

The Beast of Fallen Kings

An archetype that frequently appears in fantasy stories is that of the beast. These **intelligent monsters** are usually based on real-life animals, and a particular creature can be chosen to represent a specific character trait or personality – for example, owls are often equated with wisdom, monkeys with mischief, hyenas with cowardice and sloths with slowness or laziness. In certain cases, a combination of different animals can be used to convey a dramatic, **complex character type** such as in this illustration, which shows a beast comprising parts of a tiger, a ram and a black dragon. This sort of character design has **precedents in Ancient Greek mythological beasts** such as the multi-headed Hydra, or the three-headed, snake-tailed hound Cerberus who guarded the gates to Hades.

Explore Character Archetypes: The Ghost

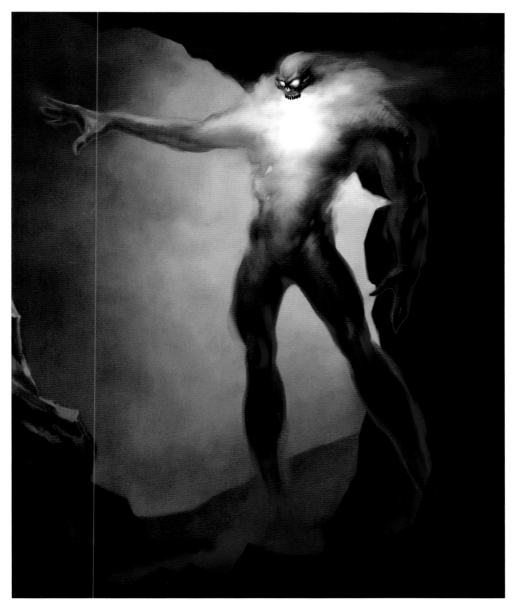

Copyright © Wizards of the Coast, Inc.
Used with permission.

The Forgewraith

Apparitions, spirits, wraiths, phantoms, spectres and other **ethereal beings** have long been a part of many of the world's myths and stories. In the fantasy realm, ghost figures or undead creatures, such as the Forgewraith, often exhibit powers or flight, incorporeality and other **supernatural abilities**. Successfully illustrating a ghost can usually be accomplished by indicating one or more of these factors — by showing the character floating, moving through solid objects or changing shape.

Although the ghost figure is incorporeal, creating a design with a face (or something serving a similar function) gives the viewer a way to relate to the creature as a distinct personality.

031 Explore Character Archetypes: The Beast Man

Gatekeeper Mystagogue

Fantasy stories are well known for their portrayal of the archetypal beast-man, which includes creatures such as orcs, goblins and trolls. The beast man is usually depicted as an **inferior form of human**, or sometimes a combination of man and brutish animal, with slightly **lower intelligence** than a normal person. This archetype can be represented by adding one or two visually dramatic components, such as tusks, lizard-like skin, horns or claws, to a humanoid body shape.

Symbionts

Fantasy characters, in particular witches, sorceresses or other users of magic, will often be accompanied by **intelligent creatures** known as familiars. Sometimes these familiars might be recognizable real-world creatures (although they should exhibit behaviour quite unlike their natural counterparts), or, as in this illustration, they can take the form of monstrous or unusual creatures. Including a familiar alongside your primary character provides another outlet for expressing a **particular personality trait**, which is especially useful if the character in your scene already has a complex story.

Artist's Tip

COMBINING VISUAL CUES FROM DIFFERENT, UNRELATED SOURCES CAN SOMETIMES RESULT IN SOME INTERESTING AND UNUSUAL-LOOKING CREATURES. ARTIFICIAL OR MANMADE MATERIALS SUCH AS MOULDED RUBBER OR ANODIZED METALS HAVE SPECIFIC REFLECTIVE AND COLOUR QUALITIES THAT ARE NOT NORMALLY FOUND IN NATURE. RENDERING CREATURES WITH MATERIALS LIKE THIS CAN GIVE THEM A SURREAL, OTHERWORLDLY APPEARANCE.

033 Explore Character Archetypes: The Winged Character

Succubus

In the fantasy genre, characters with wings are almost as common as characters possessing other animal traits, and in some cases more so. If human flight were a reality, in order to support the weight of even a small person, the wings would have to be incredibly large. Try to acknowledge this **physical requirement** by making the **proportions** of a winged humanoid character approximate to those of a real-world flying creature, such as a bird or a bat.

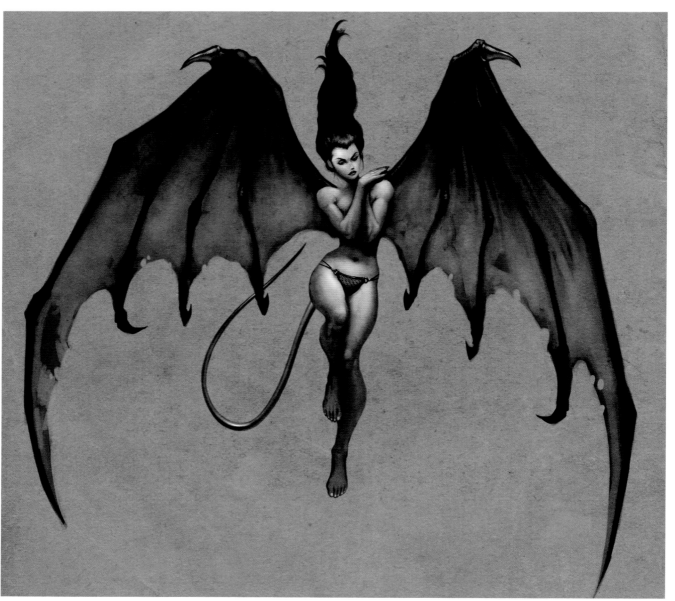

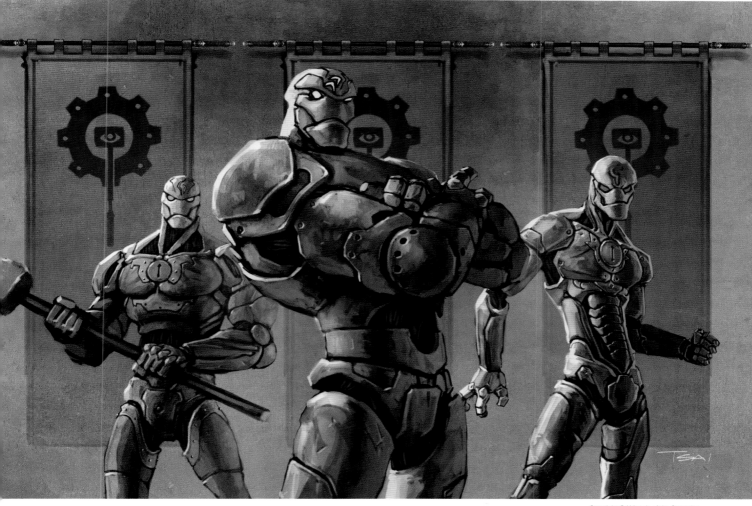

Iron Watch

The word 'golem' has its origins in Jewish folklore, and refers to a creature that is **created from inanimate matter**. This type of character appears in both fantasy and science fiction genres. In the fantasy world, golem-type creatures such as the three 'war-forged' characters in this illustration, usually have **supernatural origins**, brought to life from inert materials by a wizard or other magical character. Any depiction of a golem should exhibit the **physical scars** that show it has been artificially created or assembled; for example, seams, stitches, mechanical joints or other **signs of construction**.

The presence of what looks like a key/lock device, along with the rivets and plates, reinforces the idea that these creatures are mechanical rather than natural beings.

Establishing a Process

There are numerous design strategies that can be used to help flesh out your fantasy characters. The tips in this section discuss ways in which your initial ideas and concepts can be developed and refined on paper or on the screen, exploring and evaluating different directions you might like to go in. These are not limited to specific types of characters, but can be applied to many different situations.

The Aboleth is a sea creature whose design draws inspiration from real-life animals, but is clearly a creature of fantasy.

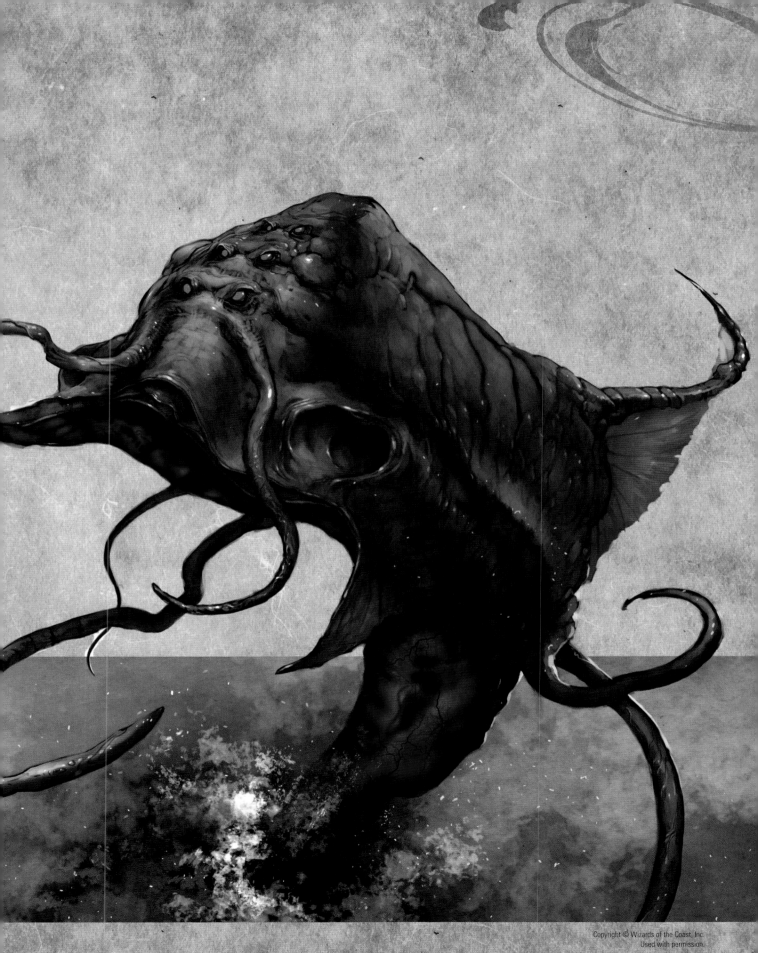

The use of red as a spot colour recalls a spider's multiple eyes, or the markings on specific kinds of spiders, such as the hourglass shape on a black widow.

Drow High Priestess

One way to approach character design is to find a major visual 'hook' or **distinguishing characteristic** that a viewer is able to identify and recognize easily. This can also serve as a **mnemonic device** to remind us of the character's pertinent back-story or other critical information. The hook in this illustration is the drow priestess's costume, which is heavily based on the spider motif so crucial to drow culture (see page 39). She has web patterns over her skirt and boots, and the angles and lines in the costume, including the gloves and headpiece, **reinforce the shapes** formed by the webs. Finally, a spider graphic in the background bolsters the theme.

Determine a
Visual Hierarchy

Creature Design Sketches

Creating visual hooks in a character design is helpful for establishing a solid, memorable identity. However, these **hooks should be limited** to two or three at most, as too much information can cloud your message. Determine which of these features is the most important, and **keep this hierarchy in mind** when designing the character. In this set of sketches for a semi-intelligent, slow-moving plant-like creature, I've explored several directions: variations on silhouette, from tall and skinny to more rounded and pear-shaped; floating versus legs; distinct head and limb shapes versus a more amorphous form. Using all these different design elements on a single illustration would result in a weak, unmemorable image. Having generated these sketches, I now need to decide which two or three aspects feel most appropriate, and of those which is **most important visually**.

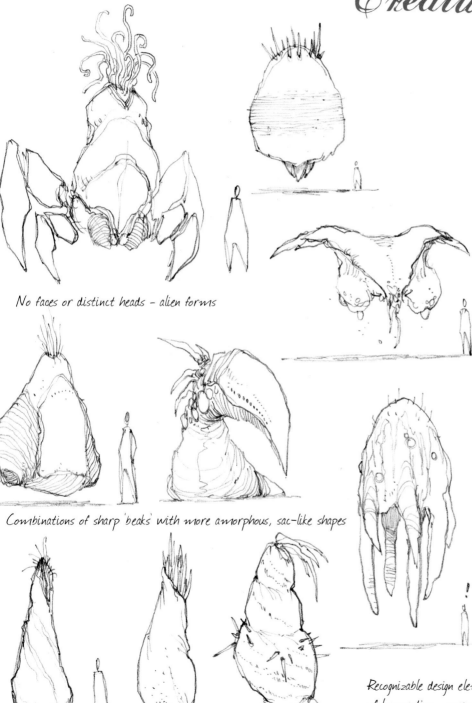

No faces or distinct heads – alien forms

Combinations of sharp 'beaks' with more amorphous, sac-like shapes

Recognizable design elements in the means of locomotion – many opportunities for enhancing the alien feel through how the creature moves

Establishing a Process

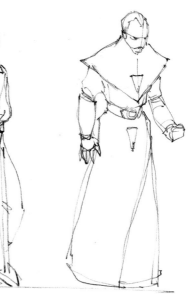

Character Ideas

Different sources of inspiration: fashion design, simple geometric patterns, and interpretations of basic human lines and forms

When you are sketching out your character design ideas, the first drawings you make often have a **spontaneous, energetic quality** that it would be great to preserve in the final illustration. However, in these initial drawings the ideas and concepts might not be conveyed in the most effective way. The value in your preliminary sketches is their natural quality – they are a **subconscious reaction** to the character you are imagining. The key is to lay out a catalogue of ideas that can be **refined and edited** later. The term 'iteration' simply refers to the different variations of your initial idea, exploring new options and **areas of emphasis** with each subsequent drawing. These sketches show some clothing designs for soldiers and priests of a fictitious medieval city-state. They are not all successful, but there are some interesting silhouettes and shape details that I can use later in more refined designs.

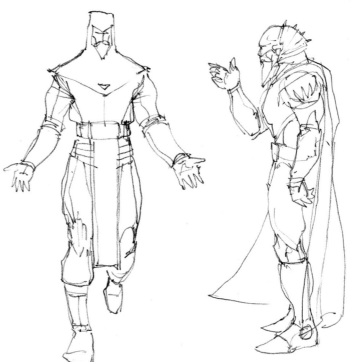

Not important to be orderly and logical – jot down ideas and save the editing and organization for later

Call Out Details

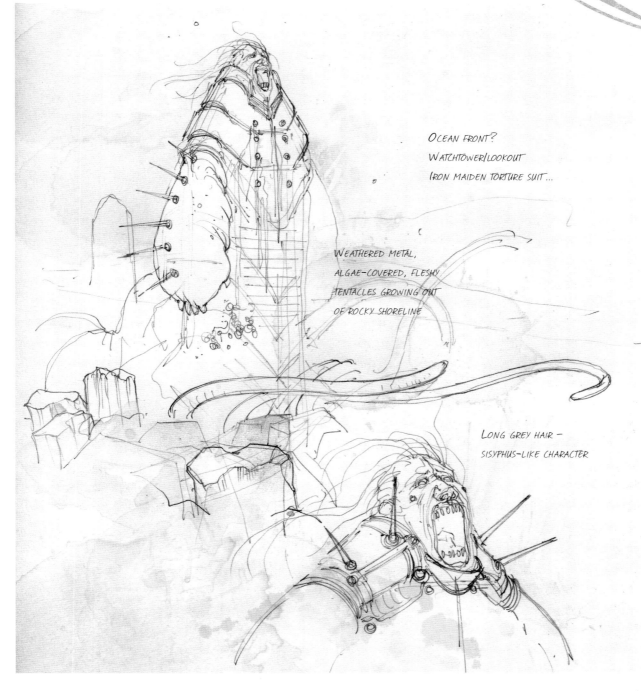

OCEAN FRONT?
WATCHTOWER/LOOKOUT
IRON MAIDEN TORTURE SUIT...

WEATHERED METAL,
ALGAE-COVERED, FLESHY
TENTACLES GROWING OUT
OF ROCKY SHORELINE

LONG GREY HAIR –
SISYPHUS-LIKE CHARACTER

Face Analysis

In architectural drawings, a small section of a plan will often be **drawn at a larger size** in order to show more detail, for example an important connection or joint. This is known as 'calling out a detail'. This is a tool you can borrow for the same purpose with your character sketches. During the process of designing different ideas for characters, there might be an instance where you would like to enlarge a certain part of the drawing to **explore some finer features**. In this sketch, I wanted to take a closer look at the face of the character, to see what kinds of expressions might be appropriate for the final illustration.

Mythical/religious figure but portrayed in a fairly realistic fashion

Human-like proportions help to emphasize the fantastic nature of his appearance

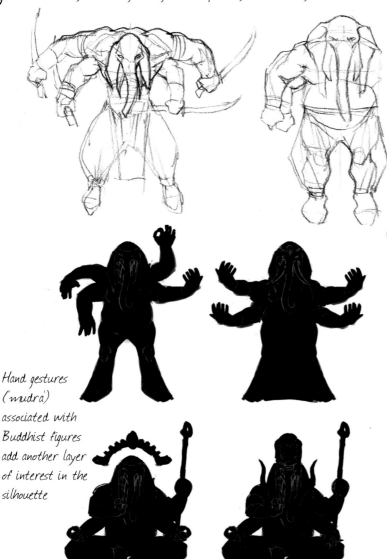

Hand gestures (mudra) associated with Buddhist figures add another layer of interest in the silhouette

Ganesh Studies

One of the primary ways in which we recognize a character is through its silhouette. This is **the main graphic 'read'** of a character, over and above details, textures and to a certain extent even colour. From a distance, textures and details are obscured, and lighting conditions can affect how colour is perceived, but rarely will a character's silhouette be altered by environmental conditions. A silhouette can be **transformed** by many different factors, such as clothing, tools or weapons, body style, or even body parts like horns, tails, hooves or wings. This set of thumbnails shows some explorations of silhouettes for a painting of Ganesh, the Hindu god. Ganesh is an established figure with certain aspects that I wanted to explore and experiment with; the mixture of human and elephant forms, the extra arms, and various instruments and artefacts.

Aboleth

In some instances, a character or creature in a fantasy setting will be alien or amorphous enough that it can become difficult to get a sense of the character's physiology or the logic behind its design. In a case like this it can be helpful to **include certain landmarks** or points of reference, so that a viewer can perceive some sort of order. For example, in this design for a large creature called an Aboleth, I have

relied on a few **familiar visual cues** to enable the viewer to understand the form of the creature. Symmetrical features like the eyes, the paired sets of tentacles and the triangular fore-fins tell the viewer that the creature possesses **bilateral symmetry** (left–right symmetry, like most animals and human beings). Without these aspects, it could be difficult to tell much about its shape.

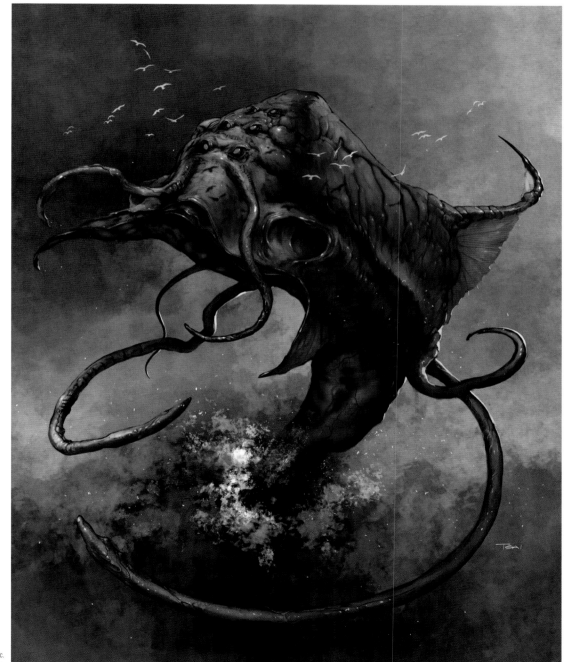

100 Ways to Create Fantasy Figures

Medusa Sketch

Symmetry and asymmetry as **design statements** tend to be more successful when they are clear and definite aspects of your characters. This preliminary sketch of a Medusa-like figure is an example where it has yet to be decided which way to go in that respect. The headdress is a primary element here, but it is not yet clear if the design is meant to be symmetrical or asymmetrical. To move forwards with this, my strategy would be to **refine the shape** of the headgear so that it is clearly one or the other. Leaving **ambiguity** in terms of symmetry just makes it appear as though you have made errors, or that you weren't able to draw accurately enough to show symmetry in the design.

Aim for Symmetry

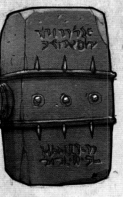

Warrior

Human standards of beauty usually depend on faces and bodies exhibiting clear left–right (bilateral) symmetry. This is a useful point to remember, even if in real life people rarely exhibit perfectly symmetrical features. In the field of entertainment design, the tendency is to portray **ideals and extremes** in character design for the sake of clarity – people are either idealized and beautiful, or very grotesque and scary. Physical symmetry is a visual cue among human beings that suggests health, vigour and attractiveness. Reinforcing this with symmetry in the costume design as well, as in this illustration, can help to convey the message of **physical perfection**.

Kettle Head

If you are including asymmetrical elements in your character, it is better to be definite about them. Asymmetry as a design statement can create interesting **visual tension**. A design based on symmetry can have a rigid feel, whereas adding a component that clearly favours one side or another adds a certain dynamic, off-balance quality. The main thing to remember is that making something very subtly asymmetrical just looks like you have made a mistake, so you need to **make it obvious**. In this illustration, the difference in size of the character's arms is emphasized as much as possible; the feeling of tension comes from the effort of the character to compensate for the weight of the large arm by leaning over to the other side. This character would not fit the standard definition of beauty, but is far more interesting as a result.

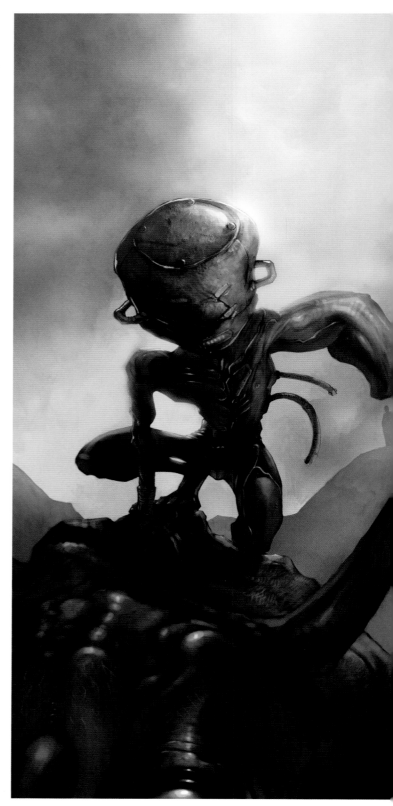

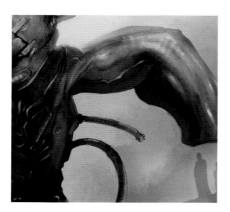

The arm with no hand is the more muscular one, as this character uses interchangeable mechanical prostheses on his stronger arm, requiring more muscle mass to move the heavy armatures around.

All of these characters are more or less symmetrical when viewed from the front

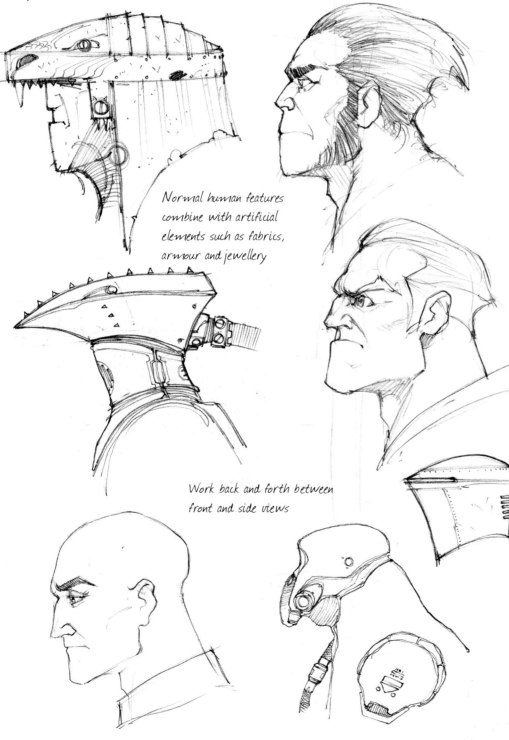

Normal human features combine with artificial elements such as fabrics, armour and jewellery

Work back and forth between front and side views

Head Studies

As these quick sketches show, designing heads in profile can free you up to **explore different shapes** without being bound by the constraints of symmetry. Trying to draw perfectly symmetrical and orderly faces can get in the way of building up a catalogue of ideas through initial thumbnail sketches and design iterations. Doing numerous drawings with this type of **freedom** is a great way to get the mind going, stimulating the thought process for other designs and illustrations.

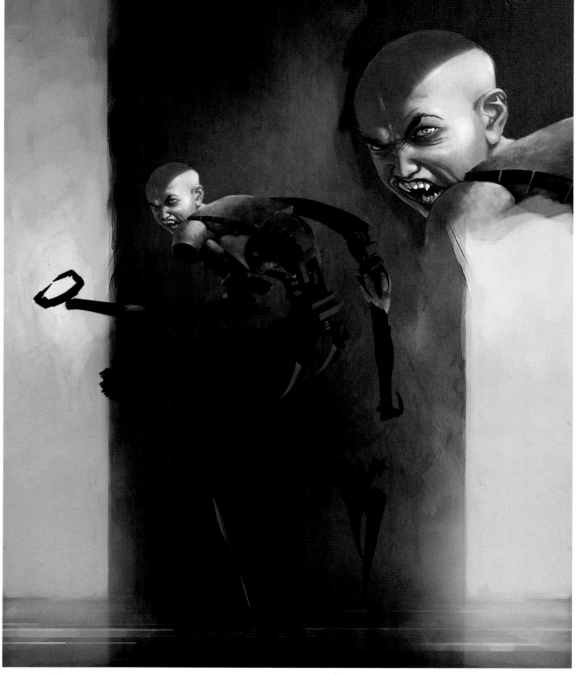

Nosferatu

The eyes are said to be the windows to the soul. In an illustration, the eyes and eyebrows are some of the key tools for **conveying personality**. In its most basic form as a classic smiley face, the eyes and mouth can convey a wide range of expressions. As this illustration shows, adding eyebrows increases the **emotional vocabulary** immensely. One thing to note is that the eyes and eyebrows are rarely symmetrical

in real life. In fact, without asymmetry in this area, faces tend to feel somewhat artificial and lacking in expression. This is an instance where you definitely want to introduce a bit of asymmetry in order to produce a convincing character. The mouth shape of the vampire in this illustration highlights the asymmetrical nature of the eyebrows, opening up the **expressive potential** of his face.

Drow Inquisitor

In entertainment design projects, such as games, comic books, or role-playing game manuals, characters often come to be closely identified with logos, graphics or certain key colours. Creating **a clear association** with a specific colour or icon is a simple but effective way of adding another dimension to your characters. Comic-book superheroes are a good example of this technique – certain superhero characters are directly associated with their logos, or particular colour combinations that echo their costume designs. In this illustration of a drow elf, I wanted to set up the deep red colour as part of her **visual identity**. Keeping the rest of the image relatively monochromatic and desaturated helped to establish the red as a distinctive design element. The colour is picked up again in the eyes of her familiar as well as in her staff.

Drow Elves

A number of individuals can be shown to be members of a group or alliance through the use of **common design elements** in clothing or equipment, similar to the way in which members of a sports team wear uniforms. In this illustration of three drow elves, each elf's armour is distinct, with different colour palettes and designs. Typically in the fantasy genre, drow elves are distinguished by spider-influenced designs, but for this particular illustration I wanted to see whether I could still convey their culture without relying on that predictable visual device. Elements such as the repeated overlapping plates and angular, downward-pointing shapes indicate that these characters are related in some way without relying on the more literal approach of covering their armour in spiders and webs.

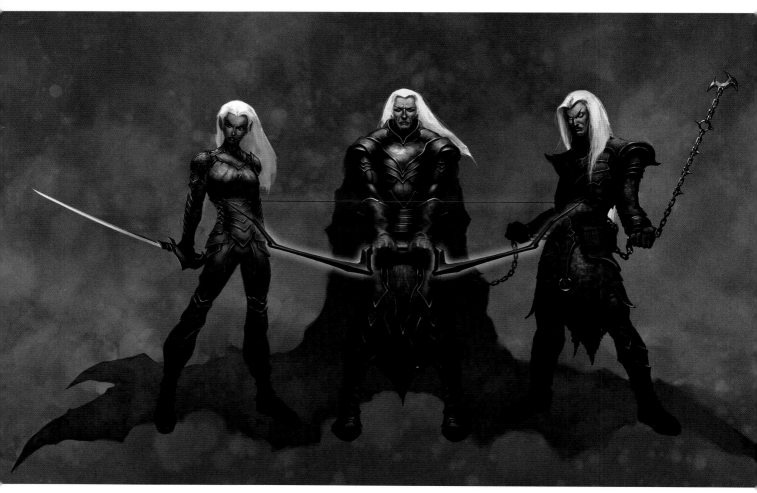

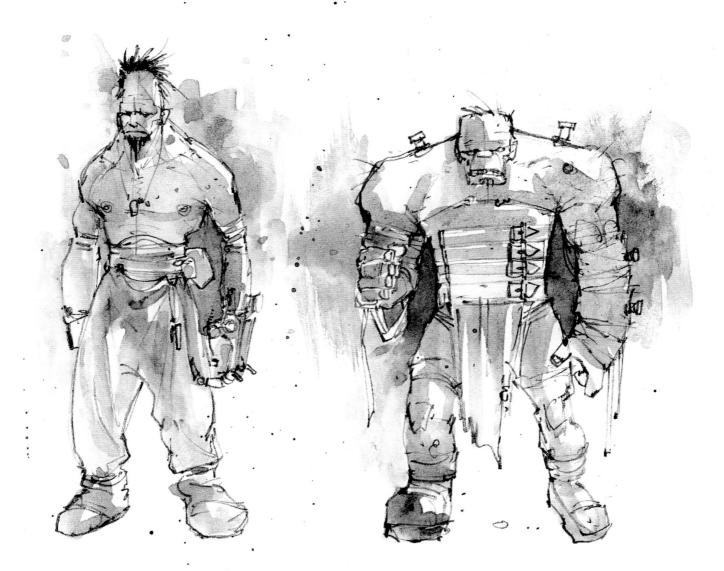

Quick Monster Sketch

Is it possible to achieve a good design in just one take? It can be, but attempting to do so can create a situation where you are too invested in an illustration to **see its faults objectively**, because you don't want to walk away from a painstakingly rendered image. It is usually better to break the process down into **small steps** that you can abandon easily if you decide that they are not working. These two sketches are from a series of explorations for a Frankenstein-like monster. They were done very quickly, with just enough detail to communicate certain design ideas. The time invested was little enough that I did not feel dejected when I came to discard them in favour of a different design later.

Preliminary Demons

Sometimes in the design process it can be helpful to **break out** of the strict procedural rules. Laying in a face and particular expression first can ground the personality of a character and help you maintain **a strong sense of their identity** as you work out the other parts of the design. In these initial layout sketches for some demonic characters, I started out with some intense facial expressions. By blocking these in first, and occasionally making the same faces myself and even some appropriate sound effects, I was able to keep a very clear sense of the **emotional quality** of the characters in my mind as I was working on them.

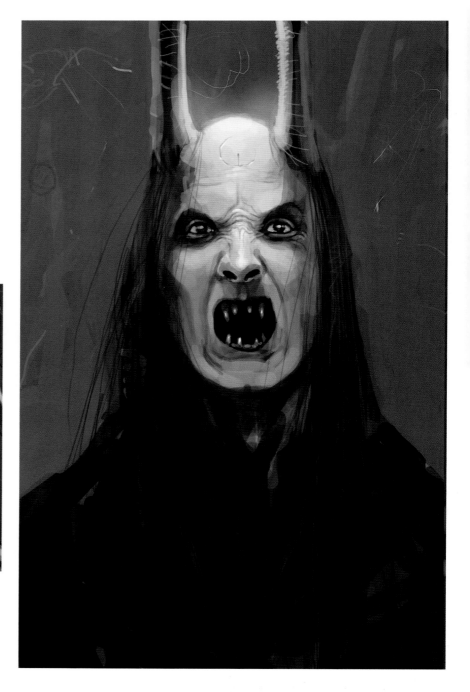

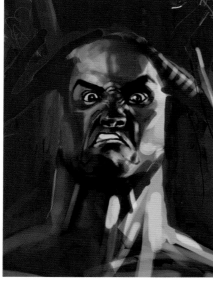

Working on the facial structure and expression at the beginning of the process helps determine the personality of the character from the outset.

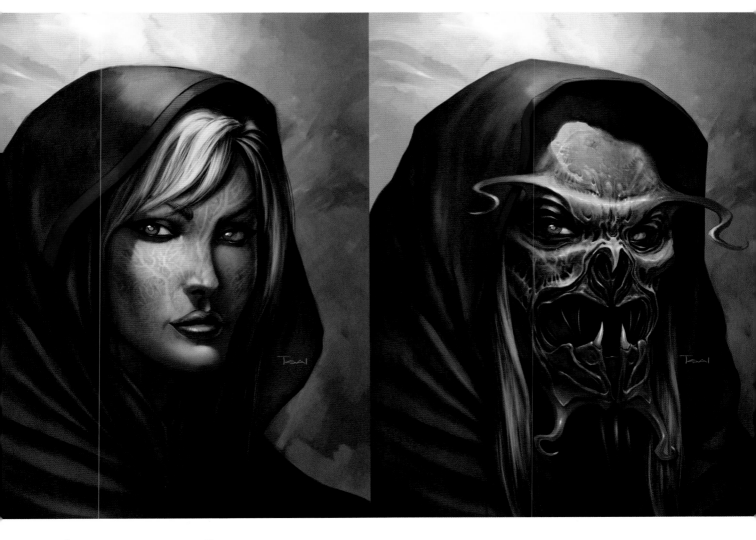

Shape Shifter

Characters with shape-shifting abilities are a common feature in many fantasy stories and games. In certain instances, different forms of the same character might need to be **linked visually**. Hints to this relationship can be provided for the viewer by including some elements in costume design or associated equipment or props that **remain constant** from one form to another. In this illustration, a shape-shifting character changes dramatically, but clues such as the overall colouration of the face and the design of the cloak indicate that they are two different versions of the same character.

A subtle texture pattern here indicates that the woman is not entirely human, and also hints at the alien quality of the skin in her other incarnation.

051 Combine Plant and Animal Influences

Green Bound Troll

Interesting variations in silhouette and texture palette can be obtained by combining human and plant forms. Plants exhibit a huge **variety of shapes and colours** that are not usually found in animal and human forms. Borrowing from this vast library can add some **striking visual effects** to your creature and character designs. In this illustration, a troll has been bound with plant and vegetable matter to create a bizarre hybrid creature.

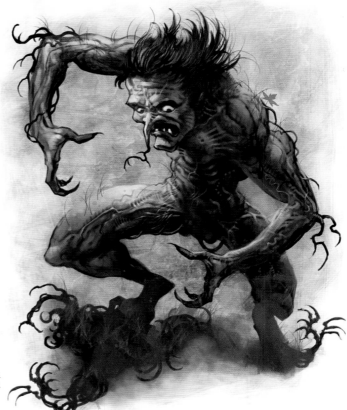

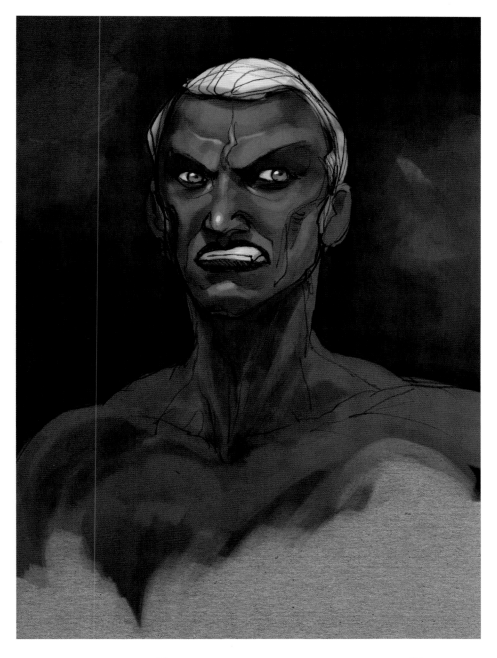

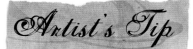

Obviously, attaching a specific numerical value to something as subjective as 'cat-ness' or 'drow-ness' is not entirely scientific. It is meant more as a rule of thumb for keeping the concept clear in your mind as you work.

Dark Half Elf

Part of the challenge for characters that are created from a **blend of different influences** (such as plant and animal, or human and mythological) is **determining the proportion** of one part to the other. Keeping an actual percentage number in mind can be a useful tool during the course of the design process. As in the case of symmetry in character design, it is generally better to be obvious about your choice. For example, in this illustration of a drow elf-inspired vampire, 80 per cent of the character is based on normal human features and proportions. The remaining 20 per cent influence is added in the form of non-human colouring, with blue skin and white hair.

Developing the Character

Once you have determined the important concepts and landmarks of a character – such as where he comes from, his favourite weapon, magical powers and so on – there are numerous ways to develop the figure visually so that those important messages are expressed in a clear way to your audience. This section looks at some thought processes and design techniques intended to help bring your message forth with the utmost clarity.

A heavily armed drow elf-priestess in her subterranean habitat.

Enhance a Silhouette:
Framing the Face

Snake Queen

For most human characters (and many non-humans), the face tends to be the **centre of focus**. Viewers look to a character's face in order to read his or her personality, emotions and mood. You can take advantage of this **natural human tendency** and play with the silhouette and shapes in this area of the body for different effects. The Snake Queen character here wears a costume with a dramatic, asymmetrical design. The arcs and points of her costume and headdress frame the face, which is the focal point in the illustration. The upward-curving shoulder plates echo the rhythm of the headpiece, and even the stray 'flaps' covering the breasts point subtly back to the face.

A simplified figure-ground diagram of the face and headgear design in this piece illustrates the strategy of framing the face using contrasting values. This same strategy was used for the Sorceress archetype on page 47.

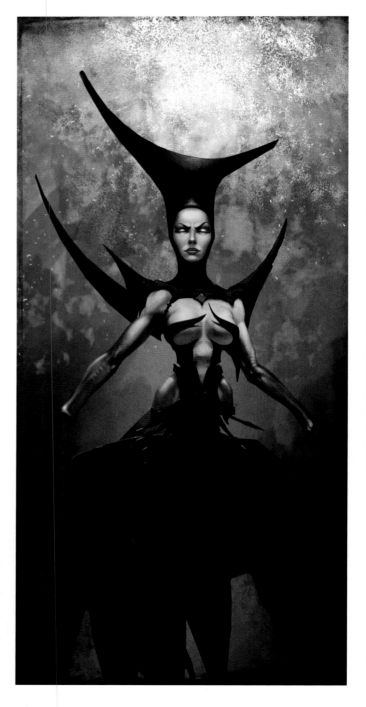

Enhance a Silhouette: Altered Physiology

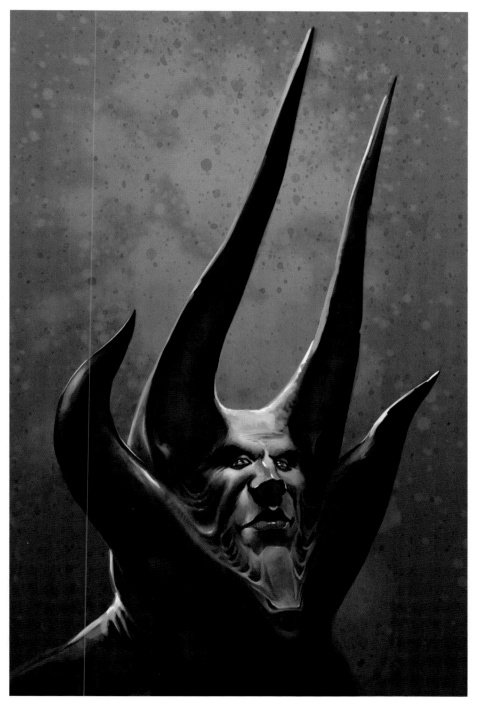

King Gronas

Another great way to enhance and play with a character's silhouette is to alter their **fundamental physiology**. The basic outline of the character's body can be transformed by adding or taking away limbs and features. In this sketch of a regal character, the head design is based on a normal human head, but with antelope and bull-like horns growing from his head and neck. These additions create **dramatic shapes** in the character's silhouette, planting him firmly in the fantasy realm.

Secondary design elements such as his complex chin structure are also borrowed from animal forms; in this case, the mouth shape from a catfish.

055 Enhance a Silhouette: Living Clothing

Secret Moondancer

For human characters, costume, clothing and equipment provide many opportunities for creating a distinctive silhouette. These elements do not have to follow body contours (and in fact in most cases it's better if they do not), and may even create an impression of being a living thing in their own right. In this illustration, the character is wearing a distinctive hooded cloak. I've taken advantage of the **amorphous nature** of the cloak, exaggerating its flowing quality to generate **a feeling of motion**. Designing the shape of the cloak also provides an opportunity **to control the composition** of the page, directing the viewer's eye towards important focal points in the image.

Enhance a Silhouette: Positive and Negative Shapes

The Sacrifice

The costume of a character provides further opportunities to augment their silhouette. By contrasting skin and clothing, or varying the **patterns of light and dark** within the clothing itself, graphic positive and negative shapes can be extracted and used to create a certain 'vocabulary', or collection of shapes for a character design. In this example, the downward-facing point is reiterated a number of times in the costume design of the standing character. The forms made by the brow of her headdress, the arc over her chest and the top of her bodice show a good example of a strong **shape vocabulary.** This graphic is echoed in the neckpiece of the masked kneeling woman.

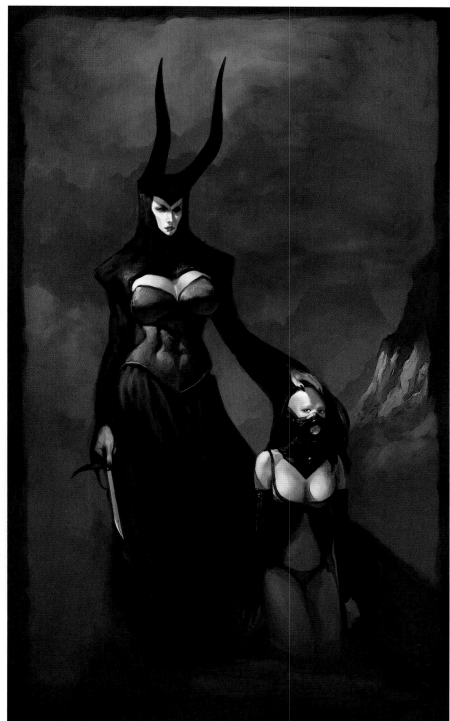

This is an earlier version of the same illustration, with more colour and texture emphasis rather than a shape-design approach.

057 Enhance a Silhouette: Organic and Inorganic Forms

The Transforming Nun

Combining elements created from different forms can create **dynamic contrasts** in a character's silhouette. Try mixing inorganic shapes such as clothing or inanimate props with anatomical shapes derived from living plants and creatures. In this illustration the angular forms of the headgear and details in the costume contrast with the sinuous, organic shapes of the tentacles coming out of the arm, creating a more **visually stimulating** silhouette and a strong image.

Artist's Tip

REMEMBER TO KEEP BUSIER, ORGANIC DETAIL, SUCH AS THE MASS OF TENTACLES IN THIS IMAGE, SUBSERVIENT TO THE OVERALL SHAPE. THE DETAILS SHOULD NOT OBSCURE OR CONFUSE THE BASIC SILHOUETTE.

Enhance a Silhouette: Animal Forms

Clytus

Another way that standard silhouettes can be altered is by combining a primarily human form with shapes borrowed from animals, or by **exaggerating certain biological forms**. Many **compelling shapes** and silhouettes can be found in nature, especially in animal features such as horns, tentacles, spikes, antennae, eye stalks and so on. In this illustration of a demonic character, a generally spiky, dragon-like aesthetic is created by adding horn shapes to the head and playing up bony protrusions at the hips and arms.

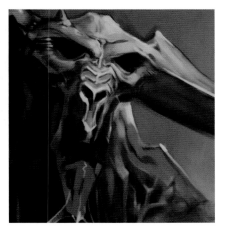

Forms and textures borrowed from nature do not have to be limited to those from the animal kingdom. Tree bark patterns, leaves, fungi, coral and so on, can also provide inspiration for colour and texture choices.

Enhance a Silhouette: Texture and Materials

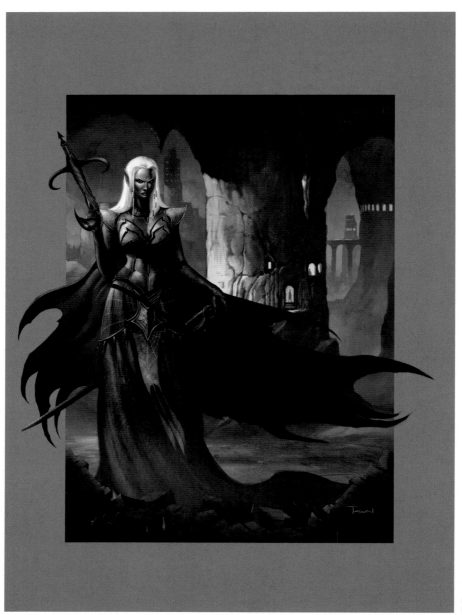

Drow of the Underdark

On page 81 we saw how contrasting shapes and patterns can be formed by the juxtaposition of light and dark values. A similar, slightly more subtle effect can be obtained using the **natural contrasts** between certain kinds of textures and materials. Some materials reflect light much more strongly than others; for example, the shiny metal of plated armour compared to the matte finish of dark leather. Placing materials with different textural and reflective properties next to each other provides another tool for creating **interesting secondary silhouettes** within a character's design. In this example, the character's armour and cloak are made up of segmented plates and overlapping forms that are separated by darker materials, creating a **strong outline**.

Introduce an Element of Strangeness

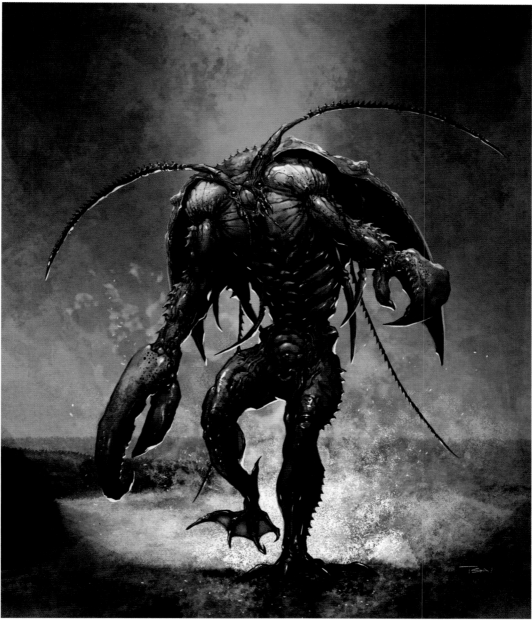

Ripper of Legend

Is this an alien creature or a human-like character? By starting from a basic humanoid framework (bilateral symmetry, two arms, two legs, etc.) a character designer can provide viewers with some familiar physical landmarks, which then allows strange and **unexpected elements** to be added to the mix without becoming too confusing to resolve. In this illustration of a character made up of many different bizarre shapes and parts, the basic bipedal humanoid signposts provide a **frame of reference** to help you understand the character's form.

061 Preserve an Element of Familiarity

Royal Engineer

An impression of intelligence and civilization can be established by adding certain familiar elements, such as real-world human clothing or equipment. Using **identifiable visual cues** enables the viewer to make a **genuine connection** to otherwise peculiar-looking characters. In this illustration, a very alien silhouette has been combined with a clothing style that is familiar to all of us – a hooded cloak. This gives the creature a scholarly and cerebral air that would not be present without this recognizable visual reference.

Providing a strong edge contrast (such as with the red stripe in the creature's hood) makes it clear to the viewer where the skin of the creature stops and the fabric begins.

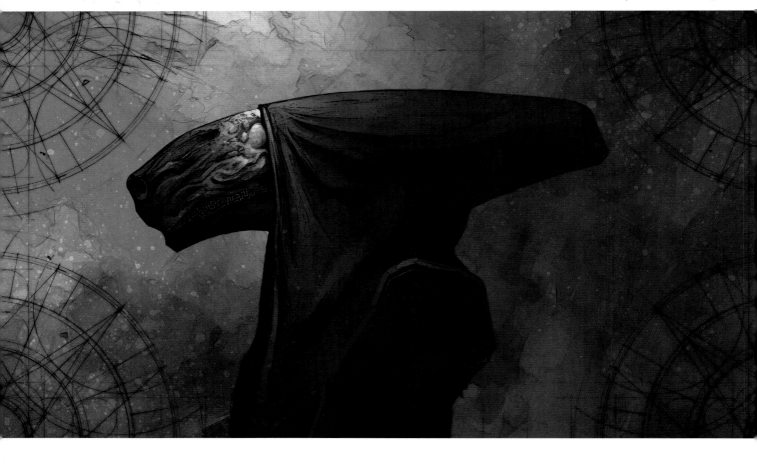

Provoke a Reaction with the Uncanny Valley

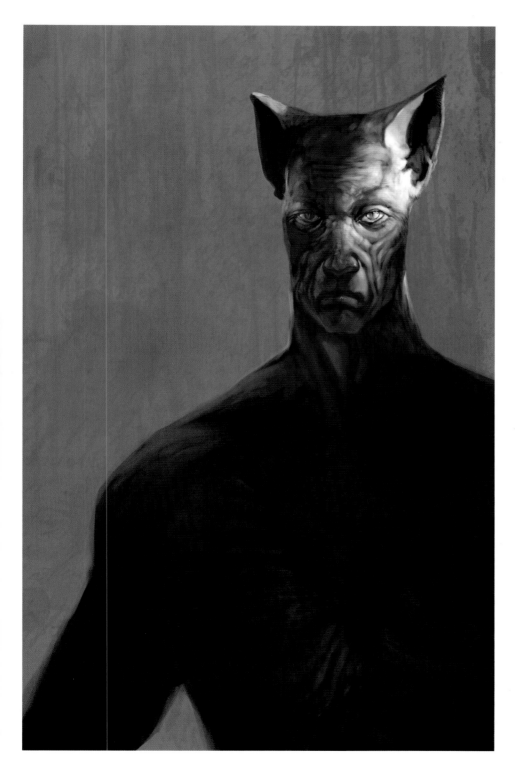

Felis

The term '**uncanny valley**' was coined by a Japanese scientist named Masahiro Mori, and refers to a phenomenon that occurs when a creature or character begins to very closely resemble a human being, except for one or two key areas. The more closely something looks like a real person, the more **empathy** a viewer will feel with it, until at a certain point the resemblance is so close that any difference or irregularity feels very **disturbing**. Here, the character is realistically rendered, with just a few **subtle changes** to his physiology to reflect a cat influence. The effect causes this character to be far more unsettling than, say, the bipedal lobster character on page 85.

Artist's Tip

SOMETIMES, A DIFFERENT PIECE OF ARTWORK CAN PROVIDE SOME INTERESTING TEXTURE OR COLOUR VARIATION THAT CAN BE PASTED INTO A NEW PIECE. IN THIS EXAMPLE, I'VE TAKEN A PIECE FROM ANOTHER ILLUSTRATION (HYACINTH) AND USED IT AS A SUBTLE OVERLAY LAYER JUST TO INTRODUCE SOME TEXTURE.

Vampire

One of the tasks I enjoy most in character design is being asked to create a monster. There are countless ways to approach this particular design issue, but a good way to start is to base your monster design on one of the **pre-existing monster archetypes** that most people are already familiar with, such as vampires, zombies, or some form of were-creature. Examples of monsters derived from any of these prototypical archetypes can be found throughout the fantasy world and offer an excellent **source of inspiration**. One of the most well known of the monster archetypes is the vampire, which has had countless different incarnations in different entertainment media.

The character in this illustration exhibits many of the hallmarks of the traditional vampire character, such as overdeveloped fangs, pale skin and blood-red eyes.

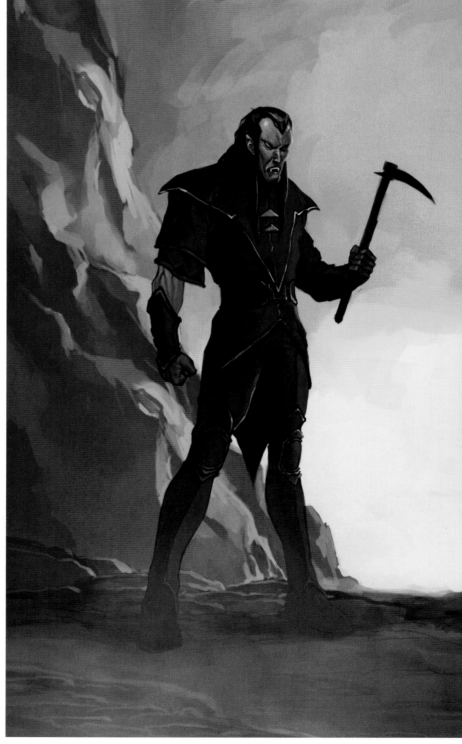

Create a Monster: Skin Deep

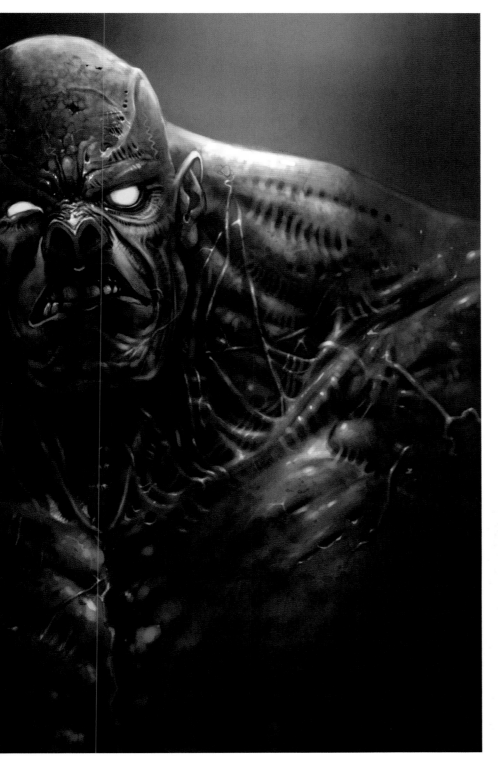

Zombo

One tactic that you can employ to great effect in your monster designs involves a **purely textural or surface approach**. The example here shows a zombie (or undead/reanimated corpse – all terms for the same concept) whose silhouette is basically that of a normal human being. The anatomy is **distorted and exaggerated** to a certain degree, but the main design statement is expressed through the character's surface quality. The imagery is intended to play up the sense of decaying skin, layers of decomposing flesh and unsightly oozing fluids.

A dimensional component also exists in the irregularities of the skin, so it reacts to light in the same way as the larger forms, creating highlights and casting shadows.

Drider

The 'Beauty and the Beast' concept can be applied to monster design for another disturbing effect. Combining traits commonly associated with monsters and visual cues that are normally related to beauty can result in a striking character or creature design. The Drider is a perfect example of this **dichotomy**. The face and upper body of this character is otherworldly in its colours and textures, but provides enough references to a standard definition of beauty to create **a jarring contrast** with the grotesque, insect-like lower body.

Separating the 'beauty' and 'beast' components makes the different aspects easier to read, but it's important to relate the two aspects visually, providing a link through colour, textures or details.

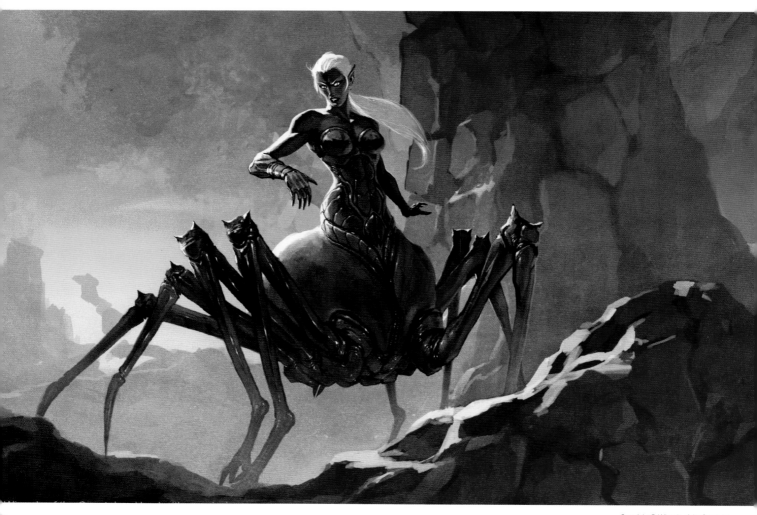

Create a Monster:
Tales of the Unexpected

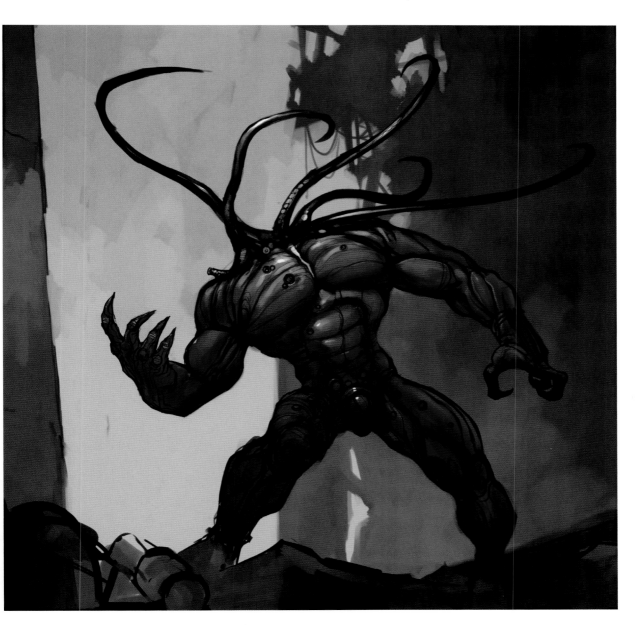

Reincarnivore

Another approach to monster design involves arranging known elements in new ways, or **playing with people's expectations** of proportions, colours, features, limbs and so on. In this illustration, the creature's head has been replaced with a set of tentacles. With characters that have an essentially humanoid silhouette, often the first place the viewer looks to determine identity is the head, specifically the face. Substituting something else where the head should be can have **a startling effect**.

Beholder

An effective creature design can come out of a strategy of **eliminating important parts** of anatomy. A monster consisting of only a head, or a headless or armless creature, has a certain **disturbing quality** that probably plays on our innate revulsion for beheadings and amputations. The Beholder is a well-known creature in the realm of fantasy role-playing games. Its key visual characteristic is that of a floating, disembodied head with a single glaring eye.

Artist's Tip

ELIMINATING OR RETAINING DIFFERENT BODY PARTS CAN HAVE DIFFERENT EFFECTS IN A DESIGN. EYES ARE USUALLY IMPORTANT IN CONVEYING A SENSE OF CONSCIOUSNESS OR INTELLIGENCE; EYE CONTACT IS A VERY DIRECT WAY TO ENGAGE WITH A PERSON OR CREATURE. ELIMINATING THE HEAD OF A CREATURE RESULTS IN MORE OF A SENSE OF MINDLESS BESTIALITY.

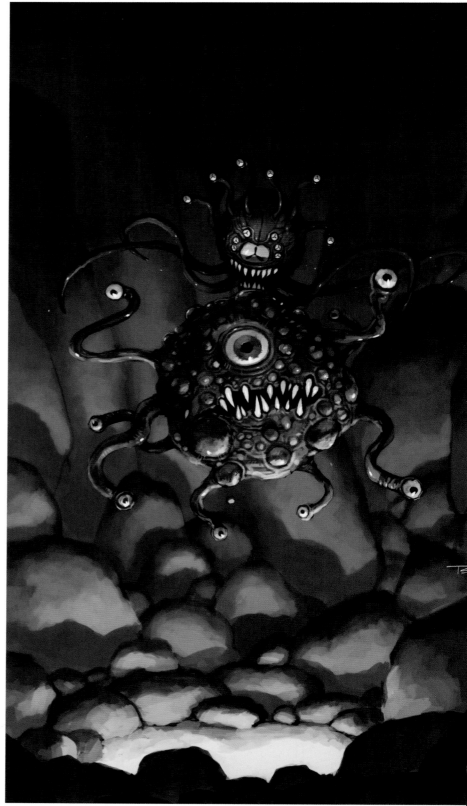

Create a Monster: Imply Possession or Infection

Dolgaunt

We've looked at a few different ways in which shapes and forms borrowed from animals can be used to alter a silhouette. In those cases, the creature or character is usually something that was born or created. One other option is to illustrate a new being that is the result of **one creature infecting or taking over another**. In a case like this, the infected or possessed character would still be recognizable, with **the horror of possession** forming the basis of the design. In this illustration, a humanoid character has been possessed by another creature that manifests as snake- and tentacle-like forms that erupt from the torso.

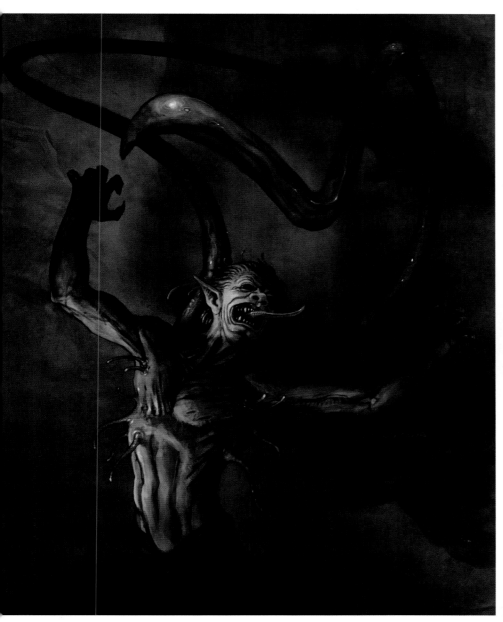

Maintaining the colours and textures of the original character in the 'infected' aspect implies that the fundamental genetic make-up of the victim has been altered by whatever is possessing it.

Developing the Character

Trebla Veladova

'Save the Cat' is a concept described by screenwriter Blake Snyder in his book of the same name. It refers to an innate human characteristic in a hero that allows the audience to identify with him. This trait is epitomized in a hero who stops to save a cat on the way to an epic calamity. It gives the character an **endearing quality** that makes him a little more human, and therefore more approachable, than a character who is superhuman but who is too 'cool' to stop for the cat. This preliminary sketch for an illustration features a character who is a master of many different disciplines. The fact that he wears glasses is uncommon for a fantasy hero, but this instantly gives him the 'save the cat' factor, making him **more approachable** than the typical muscle-bound barbarian.

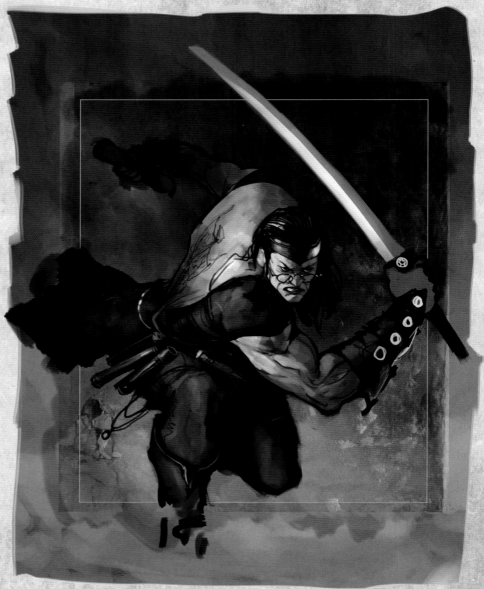

Include a Set-Piece Prop

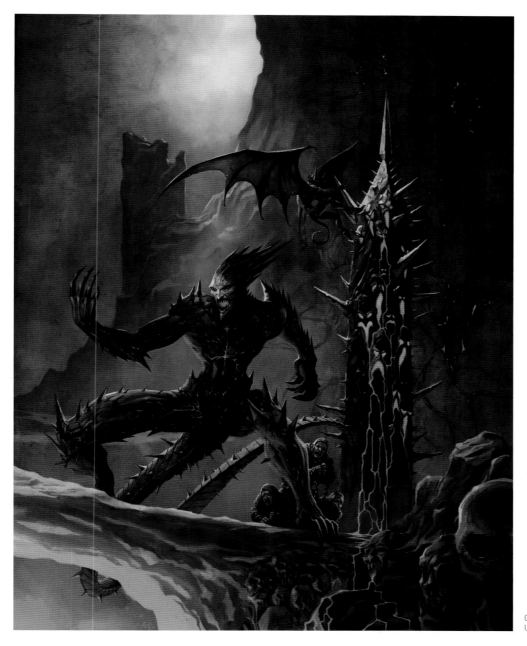

Copyright © Wizards of the Coast, Inc.
Used with permission.

Hellspike Prison

Portraying a character in a specific environment helps to strengthen the story. For example, an image of a vampire in a cave-like setting surrounded by flying bats and the mummified remains of his victims reveals more than an illustration of the same vampire on a plain white background. In any image, a character with a specific story angle or personality trait often benefits from a **visually equivalent prop**, such as a vehicle or piece of equipment that **reinforces a particular aspect** of his or her persona. In this illustration of a master of an underworld prison, a sculptural obelisk in the background echoes some of the shapes of the main character, and provides some emotional storytelling support in the expressions of the faces carved on it.

Developing the Character

Knight of the Flying Hunt

Often a character gains much of its visual impact and memorable quality by being associated with some sort of **large domesticated animal**, whether as a means of transportation or just as a travelling companion. In this illustration, the overall impression references the mounted knights who participated in medieval jousting tournaments. The addition of the wings to create a Pegasus brings the character into the fantasy realm. This particular character set-up has the added advantage of having a **very distinct silhouette**, recognizable even from far away.

Incorporate an Iconic Symbol

The Soft Claws

A character can often be represented by some sort of unique prop or piece of equipment that bears a distinctive symbol or graphic icon. This could take the form of a religious artefact or a specific tool that indicates the character's primary activity. Other examples of this idea in the fantasy realm include **flags, banners, shields and crests**, all of which can immediately **convey important information** to the viewer. In this example, a banner for a secret organization known as the 'Soft Claws' reveals its purpose of keeping watch over communities for signs of orc and dragon activity. Its leader is a dragon who takes the form of a human woman. The wings and eyes symbolize her role in watching over the townspeople, gathering intelligence, and if necessary flying to their aid.

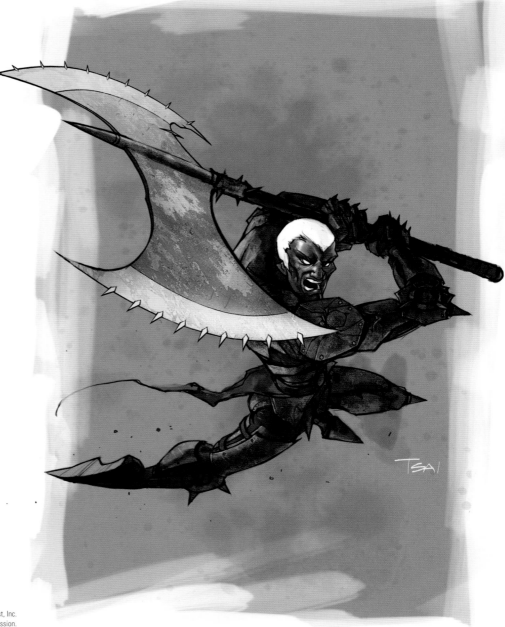

Axe Wielder

A memorable character can be created using weapons as a starting point. In science fiction and fantasy art many iconic characters are identified by their equipment and armour. Most commonly, these take the form of oversized hardware or multiple blades that **accentuate an aggressive appearance**. If a weapon is unusual or prominent enough, it can be used to form a significant aspect of a character's silhouette. In this illustration the warrior carries a large battleaxe with a distinctive double-bladed shape. From this, a secondary design characteristic has been picked out in the form of small and spiky triangular shapes that occur at regular locations on his armour.

Show the 'Unexpected Reveal'

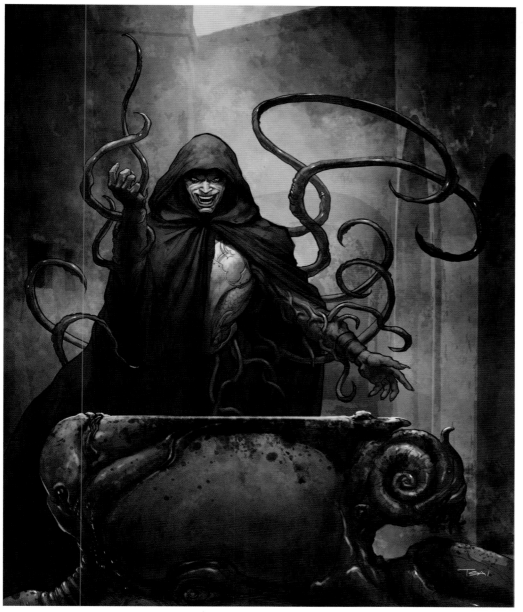

Althanis, Cleric of Dagon

Sometimes it can be dramatic to illustrate a **moment of revelation** in a story; for example, the instant a character who was thought to be human is shown to be actually part creature. This 'unexpected reveal' can inspire a dynamic image, but caution is needed. This device is a **'one liner'** that only works at a particular point in a story and should not be depended on to build a character. Design-wise there needs to be something more to avoid creating a one-dimensional role. In this illustration, the cleric is revealed to be sprouting tentacles from his body. Rather than rely on this as the main design motif, I've also included **thematic elements** of marine life – both real and mythical – in his armour and in the altar before him.

Sacrificial Altar

In certain situations you might be called upon to base an illustration on an actual culture, location or historical figure. This practice has some inherent risks such as mentally pulling the viewer out of the fantasy world you are trying to create. However, one major advantage is the **built-in recognition factor**. You can establish some **common ground** with a viewer easily by relying on imagery that to some degree they are already familiar with. The giant involved in a sacrificial rite in this illustration takes design and visual cues from ancient Central American cultures in a very direct way, making him unmistakably Aztec in origin.

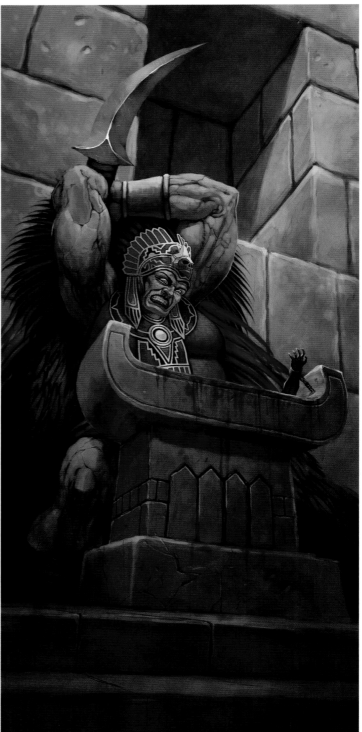

Some of the patterns and colour choices in the giant's headdress are borrowed from the design of an Aztec priest's garb.

Use Subtle References to Evoke a Theme

Rothan

While using overt references can instantly identify a character (see page 100), using **subtler signs** can create more of a general impression without sending such an explicit visual message. This illustration makes certain **allusions** to Middle Eastern cultures, but not obviously to any one in particular. Elements of the costume design and colour palette also suggest the medieval era, introducing a general feeling of antiquity. The overall result is largely exotic, but in a way that does not specifically reference a given ethnicity or time-period.

The main components of the costume design are blocked in first, leaving details and spot colours for later. The loose, flowing robes and protective headgear elements are borrowed from the native clothing of countries in the Middle East.

Communicating with the Viewer

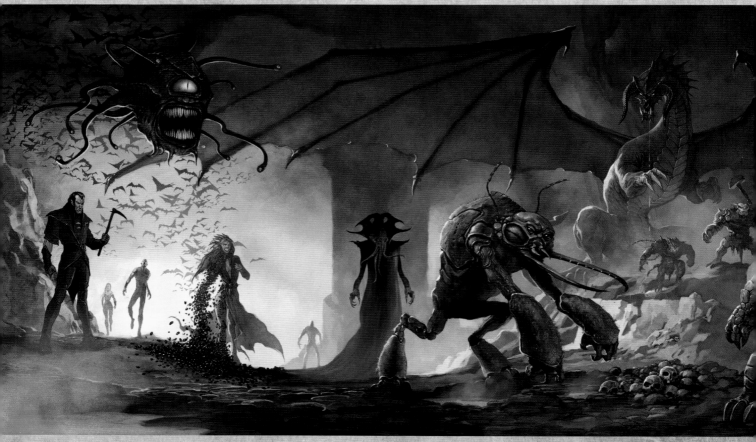

One of the most important aspects of fantasy illustration is communicating effectively with your audience. The techniques of 'visual communication' examined here show many different ways in which to clearly convey information in your images. These general practices and considerations are essentially a philosophy of execution, in that they apply no matter what character, mood, genre or medium you are using to develop your designs. Clarity is the key word. All the moves that go into creating a character should work together to transmit the same message – there should not be any elements that conflict or disagree with others.

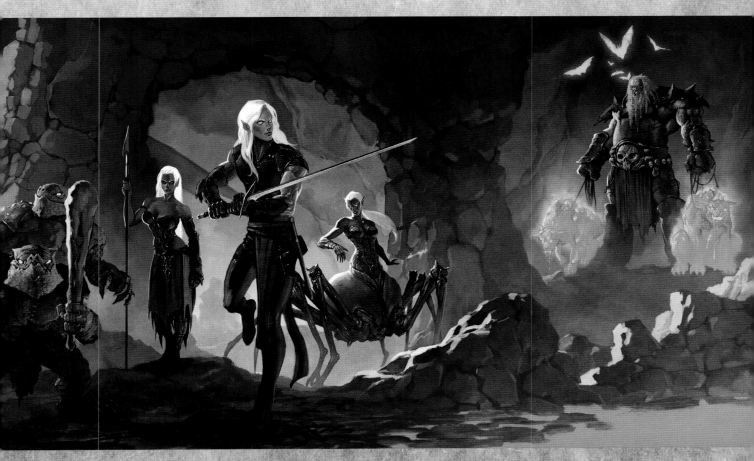

This large piece for Wizards of the Coast showcases a number of different creatures and characters. Putting together this illustration took a good deal of planning and involved a number of different practices and techniques explored in this book.

Deliberate stylistic flourishes add interest, giving the sense that the world is being interpreted through the eyes of a particular artist

Hair and clothing exhibit more ornate curling and drapery than they would in real life

Vlad Concept Sketches

A deliberately exaggerated or stylized drawing style can sometimes be appropriate in helping to communicate a particular feel or **design sense**. Rendering styles can come from a variety of sources; a decision to use a specific approach should be made for all the different characters in a given project. However, changing styles from one figure to the next will only cause confusion and won't add any value to a character design. A **uniform artistic style** that applies to all the figures in your illustration can be a very useful tool for conveying mood, and immersing the viewer in the world you create. These sketches for a comic-book character are done in a stylized manner, with amplified body proportions and facial features. By pushing reality a bit, expressions and gestures become larger than life, which is helpful in narrative media such as comics.

Use Scale References to Convey Size

Spider

If a character is not human, or if you have designed a creature where a sense of its size might be ambiguous, it can be helpful to use familiar objects or other characters to help communicate the scale. This illustration shows a creature that is based on a spider. Because a lot of the visual cues would imply a small creature, I have added a **vital scale reference** in the form of a human skeleton on the ground, wrapped in some sort of web-like material. This makes the message very clear that we are dealing with a monster many times larger than a person.

Artist's Tip

WHEN PROVIDING SCALE-GIVING PROPS AS VISUAL CUES, IT'S OBVIOUSLY IMPORTANT TO REMEMBER TO USE PROPS THAT ARE EASILY IDENTIFIABLE TO THE VIEWER. IF THEY AREN'T OBVIOUS IT DEFEATS THE PURPOSE OF INCLUDING THEM.

Guardians of Tharkgun Dhak

With a human (or human-based) figure, altering the proportions of the body is a useful tool in **communicating a character concept**. For example, creating a character with a large head and small body can feel more endearing, or at least less threatening, than a character with a small head and large body. Scale variations within a character design can also be used to express an idea – for example, a smaller head can emphasize that a humanoid character is a giant by making the arms and legs feel longer than normal, extending his reach and stride. **Scale-giving props** or gear on a character's costume can also convey this type of information. In the case of these armoured giants, rather than simply scaling up every detail in the costume, normal, human-scaled rivets, mail, connectors, scratches and dents are used – these details **relate to the viewer** in the same way that the human fighter in the scene does, helping to establish a sense of the giants' enormous size.

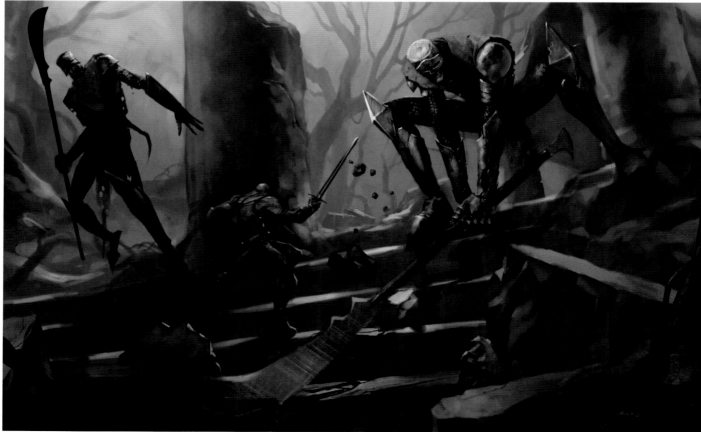

Sunlord Daelegoth Orndeir

It is a common mistake to equate lots of detail with lots of interest – in fact too much detail can kill your design, and it should therefore be **used with restraint**. The more highly worked areas you include, the less memorable each area becomes. However, clever use of detail can help to focus a viewer's attention. In this painting one of the key aspects of the visual design of the character is the fire motif. This is expressed through the character's fiery veins and the flame icon on his breastplate. This idea is also picked up in the graphic design of his shield. Adding a lot of intricacy in other areas of his clothing or armour would **dilute the impact** of these essential elements.

The colour palette in the less detailed areas of the figure has been toned down in shade and value so that the key colour areas stand out.

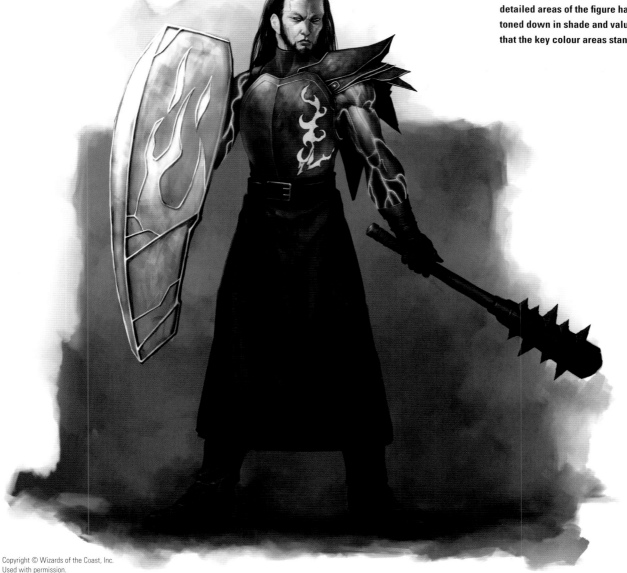

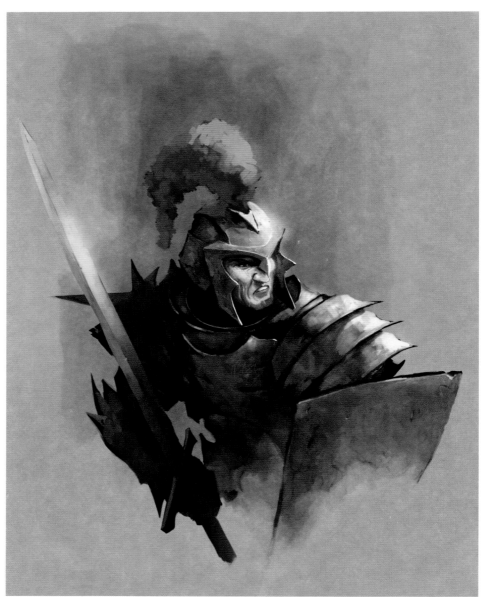

Captain Serag Kull

Occasionally, details within a costume or piece of equipment can draw attention away from another less detailed area that nonetheless needs to be a **focal point**. Because the eye is normally drawn to areas of high detail, you need to have strategies in place to counteract that **natural tendency**. This painting from the 'Mysteries of the Moonsea' game manual from Wizards of the Coast is intended to convey the aggressive, primal aspect of the character's personality. The details of the armour and equipment are **secondary in importance** to the character's face and his expression. In order to adhere to this strategy for the image, I reduced the amount of rendering in those areas, and focused the detail in and around the character's face.

The value range has been exaggerated slightly around the face, so that the increased contrast draws the eye.

Communicate Emotion Through Facial Expression

Reluctant God

One valuable device in the visual communication toolbox arises from the wide range of possible facial expressions. Almost everyone can recognize what different facial expressions mean, so a wealth of information can be conveyed through their **skilled handling**. In this illustration, the subject is an inventor who has created a time travel machine. Unfortunately, his contraption has malfunctioned, leaving him stranded in a tortured and deformed state, destined to spend eternity in this form. The body, silhouette and details are twisted beyond recognition; it is his expression that forms the **connection with the viewer**, clearly communicating his pain and anguish.

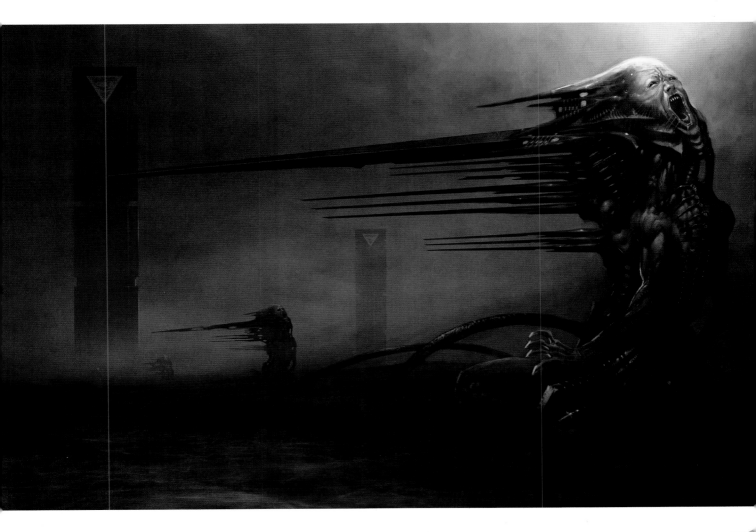

Ice Storm

Combining a dramatic scene or vista with characters reacting to and/or interacting with the environment provides a very effective **storytelling tool**. In films, remarkable events are often accompanied by reaction shots from the actors, to underpin the power of what the audience is looking at. In visual communication terms, you can borrow the same technique, using characters to add to the sense of drama you are trying to create. In this image, because the figures are walking towards the giant shipwreck in the background, it would have been difficult to show both the ship and their faces in reaction. I was able to cheat this by using the two characters lagging behind to fulfil the reaction shot function. One character gestures towards the scene and seems to be making a comment to his companion. Relating characters' activities and responses to the environment around them adds to the **sense of realism** in your image.

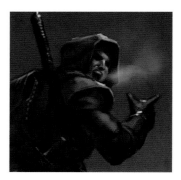

Details such as the visible breath of the characters due to the cold help place them convincingly in the environment.

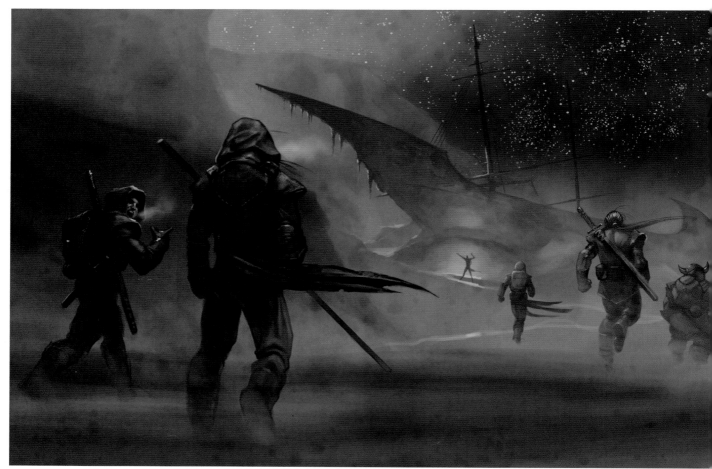

Draw on the Establishing Shot

Valenar Elf

The 'establishing shot' is a term borrowed from film. It refers to a shot that shows a view of a distant scene in order for the viewer to **understand the location** and to clearly place the action that will occur. In a film or TV context, this is usually closely followed by interior scenes within the setting shown in the first shot, which determine the relationship between interior and exterior. In a fantasy illustration context, an establishing shot can also be used to relate additional illustrations showing interior events. This image sets up a **panoramic view** of a city in a faraway valley. From this location, the details, textures and colours are obscured by mist, but this is secondary information that might be found in other types of images. The character in the scene communicates the scale and reinforces the sense of viewing from a distance by echoing the sightlines of the viewer.

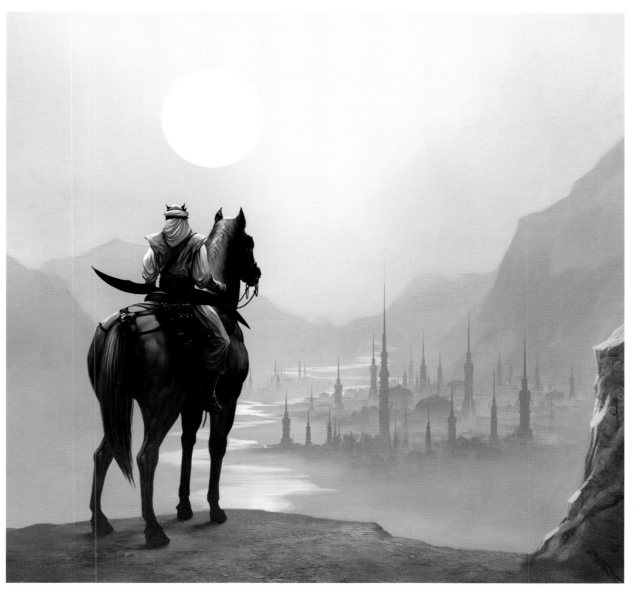

Conversation

Once the character design task is more or less completed, there are numerous ways to transmit information about a character or creature, in particular a non-human one. By **mimicking human gestures and body language**, a creature can gain an element of intelligence or personality that might otherwise be thought of as strictly a human trait. In this illustration, a female drow elf is engaged in conversation with a dragon. We can 'read' in the image that a casual dialogue is taking place thanks to a number of **visual cues**: the hand motion being used by the elf, and the relaxed stance of both parties. Because the dragon is obviously in discussion with the elf character, we can surmise that the dragon possesses a human-like level of intelligence, or at least conversational ability.

Portray the Full Range of Human Emotions

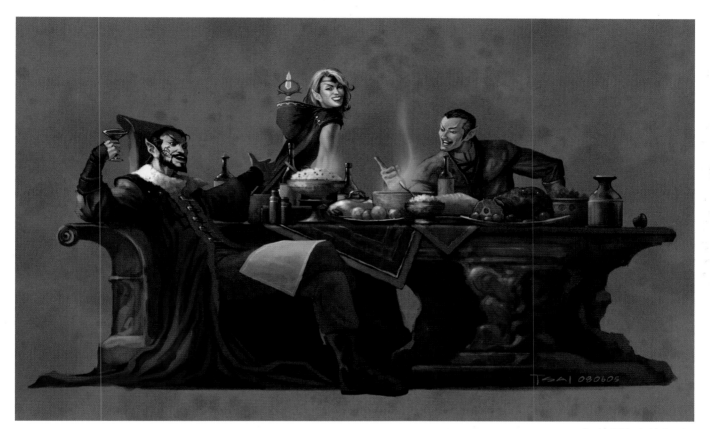

A Shared Meal

Real life is rarely full of strife and conflict, at least not to the extent of existence shown in fantasy stories and illustrations. The majority of images we see in fantasy art tend to concentrate on battle scenes, combat or some other form of clash. Showing events like that is, of course, much more dramatic than simply depicting a few friends gathering for a meal. However, a scene like this one, showing **friendly, informal interaction** can help round out the picture of fictional fantasy characters by showing that they possess a full range of emotions, and are **not simply one-dimensional**, grimacing fighting machines.

Making eye contact is one important way that people relate to one another in real life. Emulating this interaction in your characters helps imbue them with this sense of life and personality.

087 Invoke a Sense of Ceremony and Ritual

With Honour Comes Respect

In the same way that showing characters engaged in interactions other than battle and conflict helps to **enhance their realism** for the viewer, you can also rely on the natural human appreciation of ceremony to add depth to the portrayal of a character. Ritual in human culture is tied to a **shared sense of tradition**, and it can be useful to bring this feeling of history to an illustration. This scene shows a young man being honoured by an older man in a formal pageant-like way. The older man is primarily occupied with placing the medal on the younger character; most of the storytelling comes through **the expression and posture** of the younger character, which expresses his pride and respect for the ritual.

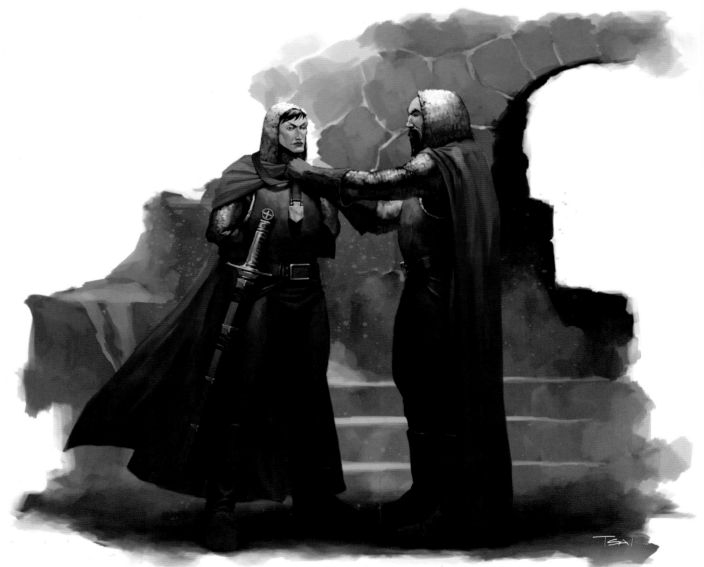

Select Rendering Style for Best Effect

Gold Knight

Once the character design has been established, the rendering technique used in an illustration can sometimes be chosen **to emphasize certain qualities** of the character. For example, this illustration of a golden knight has been rendered in a way that reinforces the battered and broken feel of the character's armour. Rather than exhibiting the clean and smooth reflective surfaces of newly polished metal, it has been rendered in an irregular and somewhat 'crusty' style, with scratches and dents in the surface. The **subtle line work and detailing** in the armour play up these defects in the metal, which tells the viewer that the knight has been involved in many battles and has suffered hardships.

In painting programs such as Photoshop, filter effects can be used to subtly enhance the textural or painterly quality of your image. Filters should be used sparingly, though – the disadvantage of using these effects is that they have a tendency to call attention to the 'digital' nature of the illustration.

Spy Games

A character actively performing a task can engage the viewer more intensely than a figure in a plain standing pose. Taking advantage of a storytelling opportunity adds **layers of information** to a character beyond simply what he wears or carries. Placing a character in a location where there is clearly a significant event taking place can add **depth and a degree of realism** to the portrayal. A specific action, such as in this image of an elf obviously involved in some act of espionage, makes a great basis for an illustration.

Being able to read some degree of intent or emotion in the character's face as he performs his action is another tool in depicting a living, breathing character.

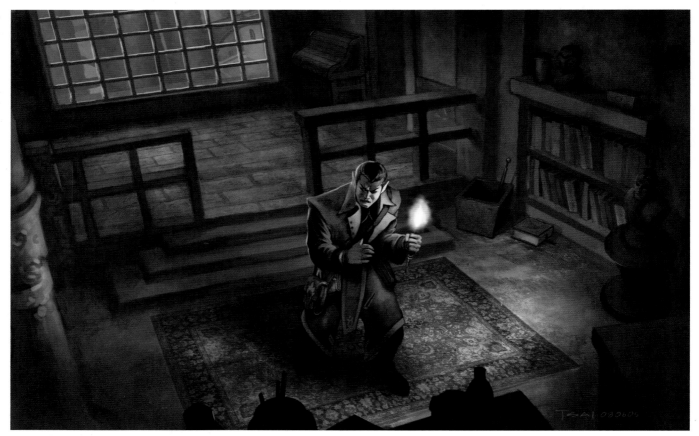

Tiamat's Wrath

Placing a character in a hostile or threatening environment can be the starting point for an effective illustration. Showing how adventurers come to find themselves in a dangerous or menacing situation is a staple of the fantasy gaming genre, and visualizing a typical climactic event such as this can help **bring the story to life** for the viewers. In this illustration, a group of explorers find themselves threatened by a manifestation of Tiamat, a multi-headed dragon creature, appearing through a mystical portal above them. The scale of the threat is magnified by the **upward angle of view**, emphasizing the size of the creature. The adventurers are almost the smallest elements in the scene, again **highlighting the scale** of the danger they face.

Artist's Tip

SOMETIMES IT CAN BE HELPFUL TO DESIGN A SPACE PRIOR TO LAYING OUT THE ILLUSTRATION, ESPECIALLY WHEN ONE OF THE MAIN CONSIDERATIONS IS SETTING UP AN EPIC-FEELING SITUATION. THINK ABOUT WAYS TO EMPHASIZE A GRAND SENSE OF SCALE, THROUGH THE USE OF OVERSIZED ELEMENTS, LIGHTING EFFECTS OR CAMERA ANGLES.

The Massacre at Drellin's Ferry

Lighting can be used to tightly control the area of contrast in an image, and in so doing provides you with another useful tool for focusing attention. The viewer's eye will be naturally drawn to the brightest areas in the scene, or the areas showing the **greatest contrast between light and dark**. In this illustration of a large-scale attack, there is no single character that is the focal point. Instead, the main impression is intended to be the moments soon after an all-out attack on a settlement by an army of giants, dragons and other creatures. The lighting in the scene is used to create an area of highest contrast along the line of buildings in the distance, creating a focal point that **supports the story element**.

The main light source is the city on fire, which has then been used to 'rim' light many of the characters and components in the scene, helping to separate them from the background.

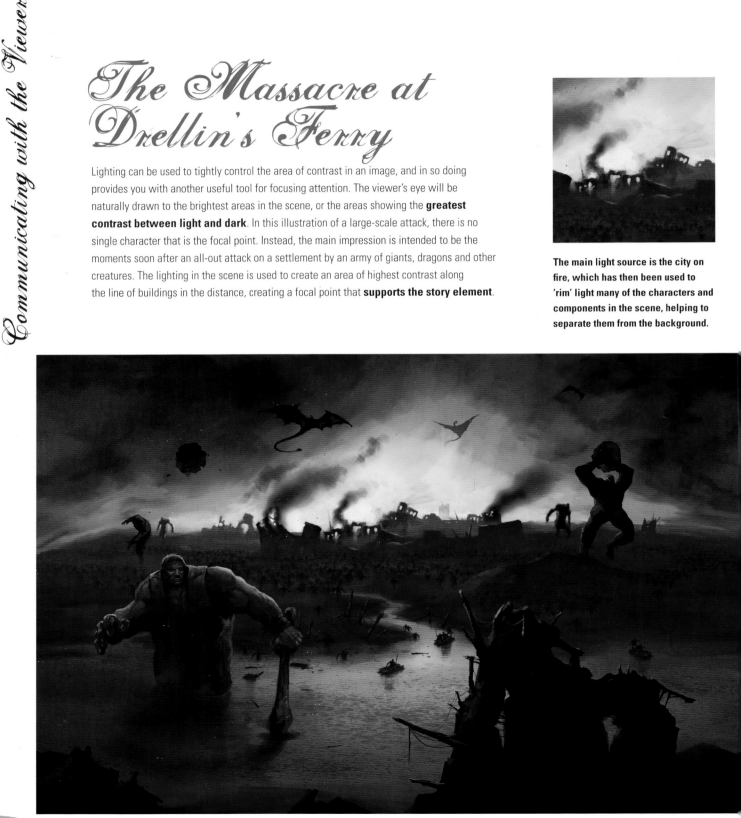

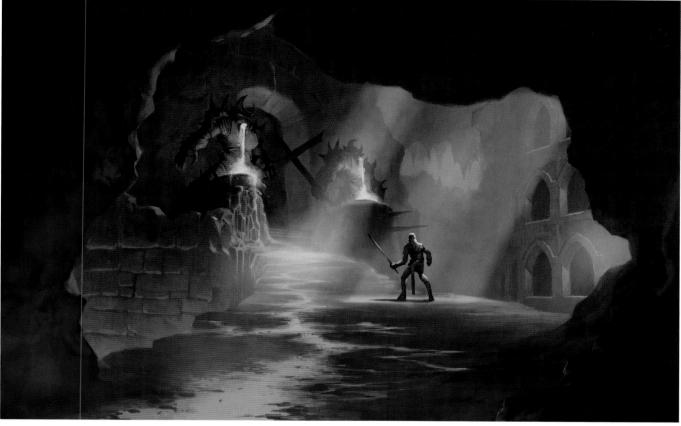

Ruins of Dorasharn

The use of lighting to create or enhance mood is itself a huge area of study, but there are some basic concepts you can take advantage of for fantasy illustration. Creating **spots of interest** in a dim environment with isolated light sources can create a feeling of mystery. Light coming from a strong sideways direction also tends to boost the **sense of drama** in a scene. In this illustration, a distinct foreground/background relationship is set up by contrasting warmer, redder light in front against the cooler shafts of downlight in the middle ground. The beams of light **frame the character**, adding to the sense of isolation. The flowing magma in the background creates uplighting on the giant statues, emphasizing the feeling of danger.

The lighting on the giant statues in the background of the scene plays up the sense of suspense and danger, and the high contrast helps draw the viewer's eye.

Behold the Lost King

There are many different ways to arrange elements in your illustrations for compositional purposes. One option is to use your characters to literally shape the image. Using **lines of sight, body language and physical interaction** is an alternative to other composition techniques that rely on 2D design (such as shapes, arcs, value changes, etc.) The character in the centre of this illustration literally points towards the undead king in the background, reinforcing him as the **centre of focus**. Additionally, elements in the landscape support the idea by pointing in the same general direction.

Show a Character Looking Off Screen

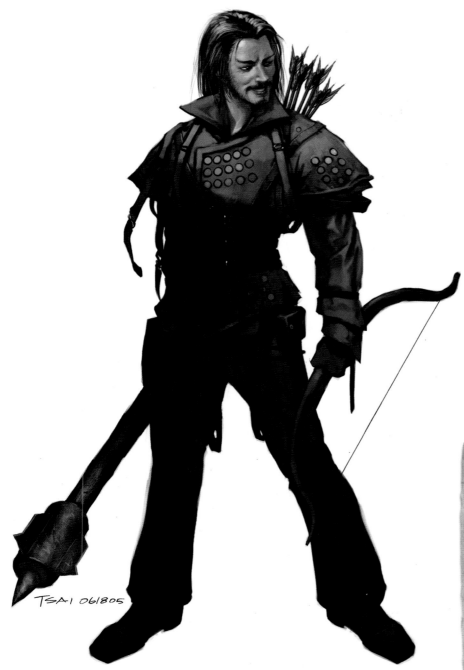

TSAI 061805

Brenvol

In an illustration, especially a simple one with a single character and no background, **directional 'weight'** in a composition can be established when a character looks off screen or off page. This creates **a psychological expectation** in the viewer, who instantly wants to know what the character is looking at, and generates an unseen 'presence' in that direction. Adding a distinct **facial expression**, whether of fear, anticipation, desire, horror, or something else can add to that sense of expectation. In this case, by manipulating the lighting so that the character's face receives most of the light, the off-screen gaze is made the focal point; details of the costume lower on the body are played down by virtue of the lighting design.

Artist's Tip

GENERALLY, WHEN ILLUSTRATING SINGLE, STANDING CHARACTERS, MY PREFERENCE IS TO HAVE A MID-TONE BACKGROUND SO THAT I HAVE THE OPPORTUNITY TO GO LIGHTER OR DARKER WITHIN THE CONFINES OF THE CHARACTER AND PLAY AGAINST THE MIDDLE TONE. WITH A PLAIN WHITE BACKGROUND SUCH AS THIS, IT CAN BE MORE OF A CHALLENGE TO AVOID MAKING THE CHARACTER'S COLOURS FEEL TOO DARK. ON THE PLUS SIDE, CREATING A SILHOUETTE EFFECT (AS IN THE LOWER HALF OF THE CHARACTER'S BODY) IS EASIER TO DO.

Races of Eberron

Colours relate to each other in certain ways, depending on where they fall on the Colour Wheel (see page 25). Brighter, more saturated colours tend to **advance forwards**, whereas the darker ones recede and **sink backwards**, particularly when they are placed next to each other. There are some interesting explanations for this phenomenon; one is that the iris of the eye reacts to vivid colours in a similar way that it reacts to bright light, by shrinking the aperture of the eye

slightly. Whatever the explanation, it is a tendency of the human eye that you can take advantage of when planning colour compositions. By modulating **the amount and saturation** of the reds in this illustration, I have made the background graphic feel more intense and weighty towards the bottom, increasing in lightness as it rises to the top. This echoes the idea of the stout, burly dwarf character down low, progressing up towards the lighter, paler character.

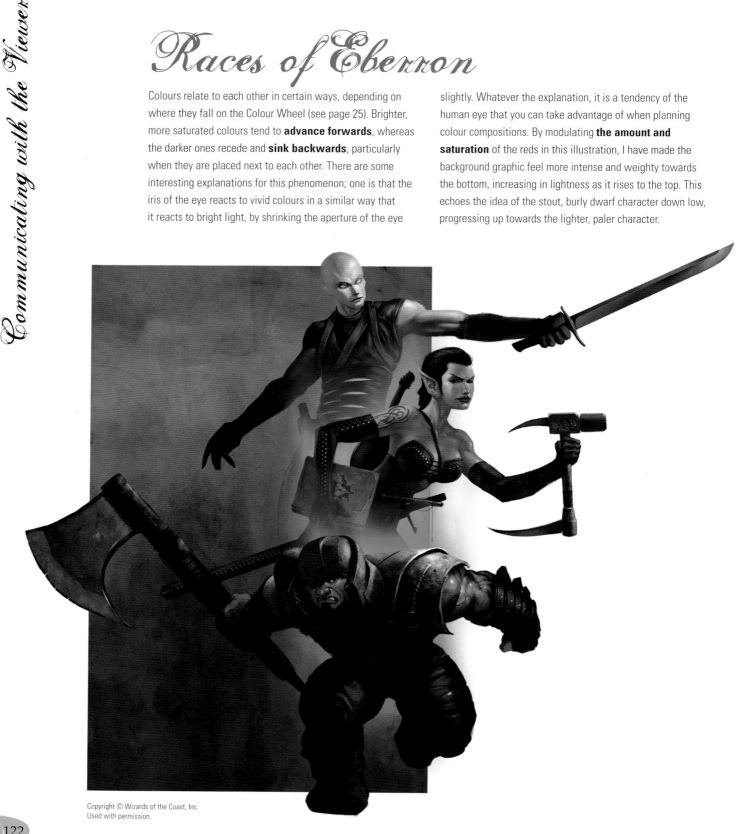

Balance Visual Weight Vertically

Drow High Priestess Sketch

A strange quirk of human perception is that we tend to perceive more weight towards the bottom of a vertical figure or composition; a vertical line that is evenly bisected will appear top-heavy. A simple vertical shape or composition actually feels more pleasing when the bisection point is **slightly higher than the halfway point**. Applying this phenomenon to character illustration, an **idealized figure** will be proportionately longer in her lower body than she would ordinarily be in real life.

Contrasting an area of relative detail with a darker, taller, less detailed shape – like this long skirt – slims the character. The darker visual mass of the lower half of her body helps to emphasize the sense of verticality.

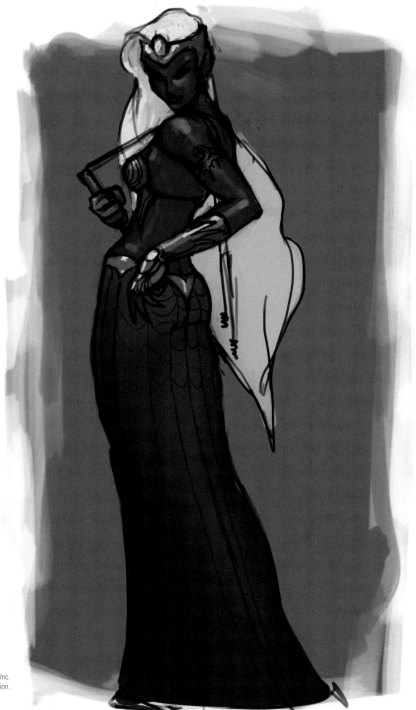

Money Well Spent

In most western cultures, viewers tend to 'read' a scene from **left to right**; because of this fact objects and characters on the right-hand side of a composition tend to carry more visual weight. There are many different tricks and techniques used **to guide a viewer's eye** across and through an illustration, but this is a built-in propensity of the human eye that you can easily use to your benefit. In this image, a hired band of mercenaries protects a merchant, fighting off a group of armed brigands. I've relied somewhat on the left-to-right read of the scene to help tell the story, with the movement of the eye ending on the main character of the story, the female half orc swinging her axe.

Create Depth
by Overlapping

Aereni Trio

A simple visual communication concept is that of overlapping forms. It might seem an obvious thing to more experienced artists, but the act of placing some characters or objects in front of others is an easy way to **create a sense of depth** in your illustration and **establish spatial relationships** between the elements in your scene. In this image the composition is fairly clean – three characters stand together with a very plain background. By overlapping elements from all three characters, I have established who is in front, who is in the middle and who is at the back. This adds a sense of depth – albeit limited – and makes the image more dynamic than simply presenting the three characters in a line with no intersecting shapes.

When working with overlapping characters pay attention to the edges – in some less important areas it's fine to 'lose' the edges. A viewer's eye naturally tends to fill in these lost edges and this can actually help make the image more engaging.

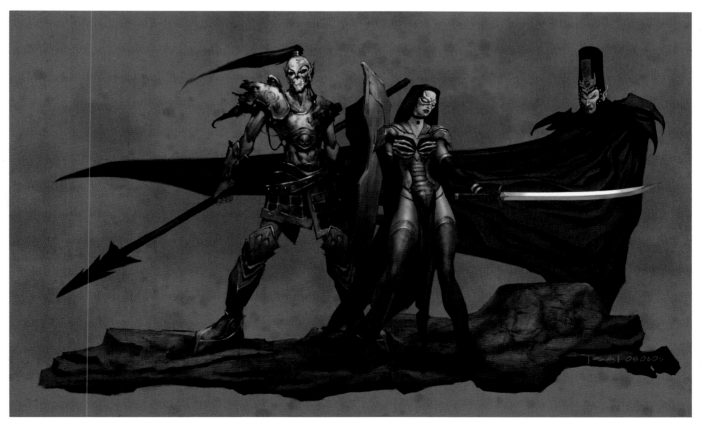

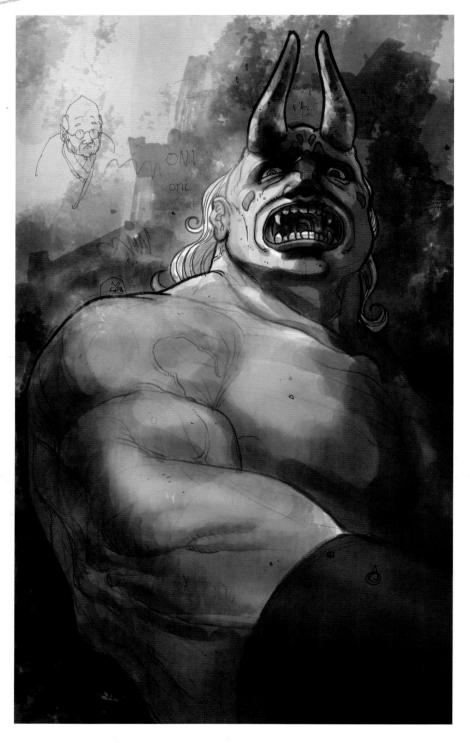

Ogre

Most of the character and creature renderings in this book were completed in Photoshop, using digital painting tools and a few filter effects. There are also a few examples of images created purely traditionally, mostly some combination of pencil, ink and markers. **Using digital tools to enhance traditional media** allows you to enjoy the strengths of both media, and to combine them for interesting effects that would be difficult to obtain using one or the other by itself. This ogre character was drawn in my journal. A simple colour pass and subtle lighting effects were added in Photoshop, **preserving much of the hand-drawn feel** of the original sketchbook image.

Digital painting programs have come a long way and can be used to create impressive results. However there is still a certain charm about a hand-drawn line that computer software is not yet able to capture successfully.

Experiment with all the Tools at Your Disposal

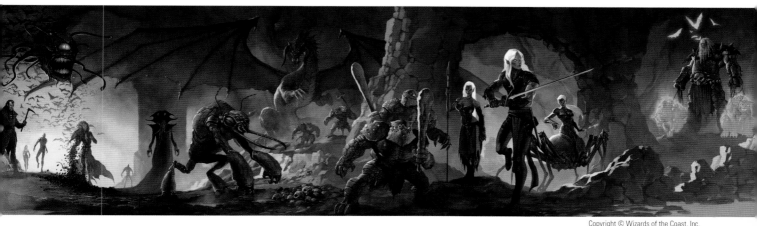

Dungeon Master Screen

I want to end with an example of a piece that incorporates many if not all of the 'ways' in this book. This large-scale piece was commissioned by Wizards of the Coast as a four-panel cover for a printed gaming product. As it involved many different types of characters, some of which I was not familiar with, it required considerable preliminary **research, sketches and studies**. The composition became a design task in itself, as I had to come up with different mechanisms to justify the lighting and colour palettes that I wanted to use. The layout sketch reproduced below shows the rough arrangement I ended up with, which formed the basis for the different **'zones' of colour**. These zones were designed to break up the odd proportions and provide some **visual rhythm** as your view pans across the

scene. Each of these zones then had to have a **logical lighting scheme** of its own to justify the colour palettes.

The point here is that creating a successful finished illustration is not an exact science. We have looked at a large number of methods to create characters, refine designs, compose illustrations and to communicate the right information to the audience. Any one technique by itself will probably not result in a perfect image (if there is such a thing). As you form your own work habits, rather than relying on just one way or making a habit of using a handful of 'favourite' techniques as a crutch, **constantly try to use different ways** and combinations of ways – some will work for certain kinds of illustrations and some won't.

VAMPIRE
LAMIA
BEHOLDER
VAMPIRE SPAWN
MIND FLAYER
UMBER HULK
DRAGON
BUGBEARS
TROGLODYTES
DROW (M)
DROW (F)
DRIDER
HELL HOUNDS
FIRE GIANTS
FIREBATS

330170010066 62

Acknowledgments

Thanks to the idols, mentors and role models: Sinclair Black, John Buscema, John Byrne, Frank Frazetta, Janet Hobbs, Joe Johnston, Ron Lemen, Todd Lockwood, Shirow Masamune, Syd Mead, Craig Mullins, Steven Olds, Neil Peart, Phil Saunders, Farzad Varahramyan, D. Andrew Vernooy and Dave Wilkins.

About the Author

Francis Tsai is a conceptual designer and illustrator whose art is used in games, television commercials, books, comics and films. He has been working in the games industry since 1998, on concept art, illustration and art direction, and has been freelance since 2006. His clients include Wizards of the Coast, Marvel Comics, Warner Brothers, Eidos Interactive, Midway Home Entertainment, Rockstar Games and *ImagineFX* magazine.

Index